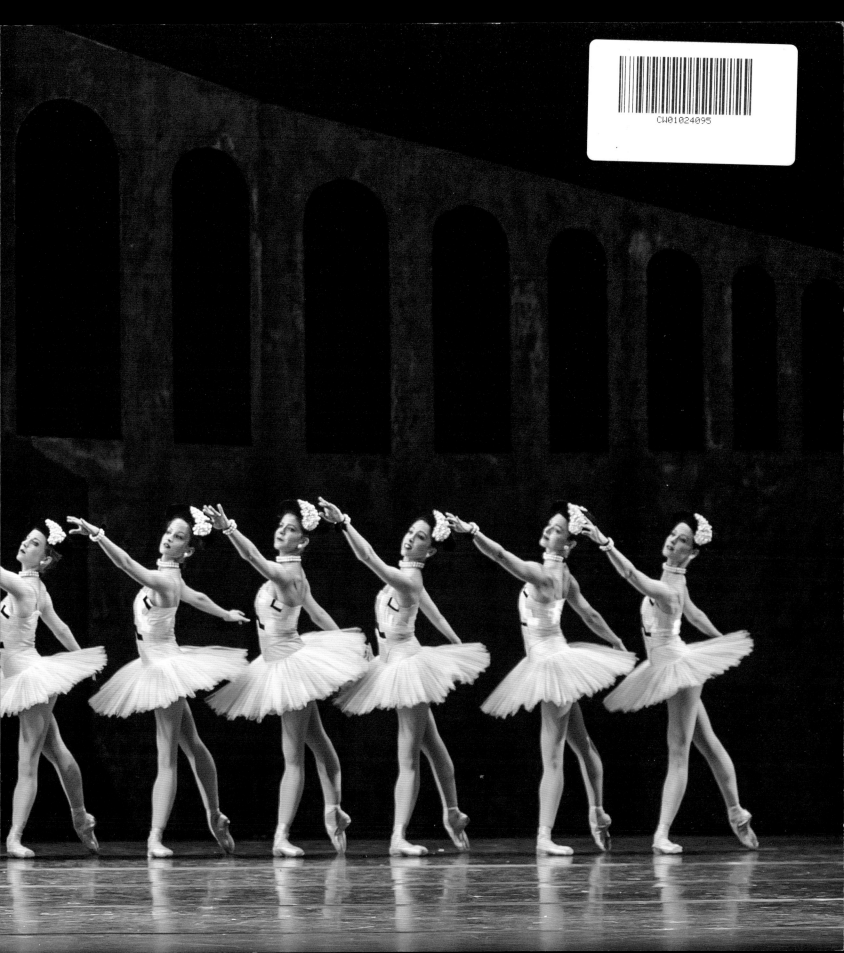

Front cover: Alessandra Ferri in Wayne McGregor's *Woolf Works* ©2015 ROH. Photograph by Tristram Kenton

Inside front cover: Artists of The Royal Ballet in Frederick Ashton's *Scènes de ballet* ©2014 ROH. Photograph by Tristram Kenton

Inside back cover: Artists of The Royal Ballet in Kenneth MacMillan's *Song of the Earth* ©2015 ROH. Photograph by Bill Cooper

Back cover: Helen Crawford in Frederick Ashton's *Five Brahms Waltzes in the Manner of Isadora Duncan* ©2014 ROH. Photograph by Tristram Kenton

First published in 2015 by the Royal Opera House
in association with Oberon Books Ltd
Oberon Books Ltd
521 Caledonian Road, London N7 9RH
Tel +44 (0)20 7607 3637
info@oberonbooks.com
www.oberonbooks.com

Compilation copyright © Royal Opera House 2015

Text copyright © Royal Opera House 2015

The Royal Opera House is hereby identified as the
author of this book in accordance with section 77
of the Copyright, Designs and Patents Act 1988.

Cover and book design: James Illman

For the Royal Opera House:

Commissioning Editor: John Snelson

Project Manager: Will Richmond

Content Production Assistant: Nicholas Manderson

Every effort has been made to trace the
copyright holders of all images reprinted in this
book. Acknowledgement is made in all cases
where the image source is available, but we
would be grateful for information about any
images where sources could not be traced.

A catalogue record for this book is available
from the British Library.

PB ISBN 978-1-78319-933-4
E ISBN 978-1-78319-934-1

Printed and bound by
CPI Group (UK) Ltd, Croydon, CR0 4YY

Royal Opera House
Covent Garden
London WC2E 9DD
Box Office +44 (0)20 7304 4000
www.roh.org.uk

ROYAL
BALLET

2015/16

Supported using public funding by

**ARTS COUNCIL
ENGLAND**

LOTTERY FUNDED

This page, clockwise from top left: Wayne McGregor, Christopher Wheeldon, Carlos Acosta, Liam Scarlett

Photo credits clockwise from top left: ©2015 ROH. Photograph by Andrej Uspenski; ©ROH/Johan Persson, 2011; ©ROH/Andrej Uspenski, 2013; ©2014 ROH. Photograph by Bill Cooper

THE 2015/16 SEASON

The 2015/16 Season will add six works to The Royal Ballet repertory, with four world premieres and two newly-commissioned scores. In addition there will be revivals of several recent ballets, favourite heritage works – some returning to the repertory after years of absence – and the biggest Live Cinema Season to date, with six ballet presentations.

Artistic Associate Christopher Wheeldon creates a new work inspired by John Singer Sargent's scandalous painting *Madame X*, to a new score by Mark-Anthony Turnage. It will be performed in a mixed programme with Wheeldon's *Within the Golden Hour* and *After the Rain* – both new to the Company. Resident Choreographer Wayne McGregor collaborates with Finnish conductor-composer Esa-Pekka Salonen on a new ballet to the latter's 2011 *Nyx*. A new production of *Carmen*, choreographed by Carlos Acosta, will also be given its premiere, in November, with a new arrangement of Bizet's music by Martin Yates.

Artist in Residence Liam Scarlett's first full-length main stage ballet, *Frankenstein*, inspired by Mary Shelley's gothic masterpiece, will receive its premiere in May, with a new score from Lowell Lieberman, whose music Scarlett used for his 2012 one-act ballet *Viscera*. Scarlett's *Viscera* will appear in the same mixed programme as *Carmen* with Jerome Robbins's *Afternoon of a Faun* and George Balanchine's *Tchaikovsky pas de deux*. Both *Frankenstein* and the *Carmen* programme will be broadcast live to over eight hundred cinemas worldwide as part of the Royal Opera House Live Cinema Season.

McGregor revives his *Raven Girl*, which he created in 2013 in collaboration with artist and writer Audrey Niffenegger. *Raven Girl* will be performed in a mixed programme with Alastair Marriott's 2014 work *Connectome*, which was inspired by the connection between the emotions and neurology. Wheeldon revives his acclaimed full-length ballet *The Winter's Tale* in the spring.

Revivals of Company heritage works include Kenneth MacMillan's *Romeo and Juliet*, which has its 50th anniversary in 2015 and opens the Season, and, in May, his controversial 1960 ballet *The Invitation*. Three works by Founder Choreographer Frederick Ashton will also be revived: *The Two Pigeons*, an exploration of the nature of love, returns to the repertory after an absence of 30 years, twinned at some performances with *Rhapsody* and at others with *Monotones I and II*, his most abstract work.

Nineteenth-century classics complete the Season's repertory, with Peter Wright's production of the Christmas favourite *The Nutcracker* returning to the stage in December and his *Giselle*, the quintessential Romantic ballet, returning in February. Both ballets will be broadcast live to cinemas, as will *Romeo and Juliet,* the *Rhapsody/The Two Pigeons* programme and *The Nutcracker*.

The Royal Ballet Studio Programme continues to present new work and projects from inside the Company and from the wider dance community. The programme features performances by visiting companies including the contemporary Québécois company Cas Public with *Symphonie Dramatique*, a modern take on *Romeo and Juliet* in September, Royal New Zealand Ballet (with a mixed programme of work by De Frutos, Ieremia, Simmons and Foniadakis) and Phoenix Dance Theatre (with new work by Galili, Watson and Finn) in November. Former Royal Ballet Principal Alessandra Ferri stars with

American Ballet Theater principal Herman Cornejo in Martha Clarke's *Chéri* (based on the novella by Colette) in the autumn.

Will Tuckett and Alasdair Middleton collaborate on a revival of their 2013 *Elizabeth* – a sophisticated fusion of dance, music and theatre about the life and loves of Elizabeth I, with a score by Martin Yates, in the Linbury Studio Theatre. After *Elizabeth* the Linbury will close as part of the Royal Opera House's major Open Up project. The Studio Programme will continue its commitment to developing new and small-scale works with initiatives and collaborations outside the building.

At the end of the 2015/16 Season the Company will tour to Japan.

COMPANY NEWS AND PROMOTIONS

JEANETTA LAURENCE, ASSOCIATE DIRECTOR

Jeanetta Laurence retired as Associate Director of The Royal Ballet at the end of the 2014/15 Season. Jeanetta had her first experience of working with a director of The Royal Ballet in 1964. Ninette de Valois, who by then had formally retired from the Company, rehearsed Jeanetta and Wayne Sleep in the roles of Red Riding Hood and the Wolf in *The Sleeping Beauty* for The Royal Ballet School's annual matinee performance. Jeanetta progressed through the School, and in her final year had regular classes with De Valois. 'It was terrifying', she remembers. 'In those days Madam, as she was called by everyone, was still very fearsome indeed – and when she was teaching a class she kept hold of her stick!'

Upon graduating, Jeanetta was offered a contract by the Royal Ballet Touring Company, and in 1970 she became one of the six corps de ballet girls in the New Group (later renamed Sadler's Wells Royal Ballet). As a dancer with these companies, she came to know De Valois in a very different way. 'De Valois mellowed considerably as she got older', she explains.

> One of the loveliest memories I have of her was that she, being Madam, as only she would, wanted to put on a little show for her local Women's Institute in Barnes. She asked Wayne Sleep, myself, Margaret Barbieri and Ashley Killar – we were all dancers in the Company at the time – to arrange a little entertainment in a tiny church hall. With everything she had become and achieved, she put just as much thought into making this little performance. She was incredible.

Jeanetta could quite justifiably speak of her own remarkable achievements with the same glowing pride. Her retirement as Associate Director of The Royal Ballet at the end of the 2014/15 Season marked the conclusion of a career with the Royal Ballet organization that spanned over half a century – including 25 years as a member of the senior management team – and she was recently awarded an OBE for services to dance. But, rather than focussing on her own successes, Jeanetta's pride is in everything that the Company as a whole has accomplished. 'The Royal Ballet is an astonishing institution', she explains. 'It's

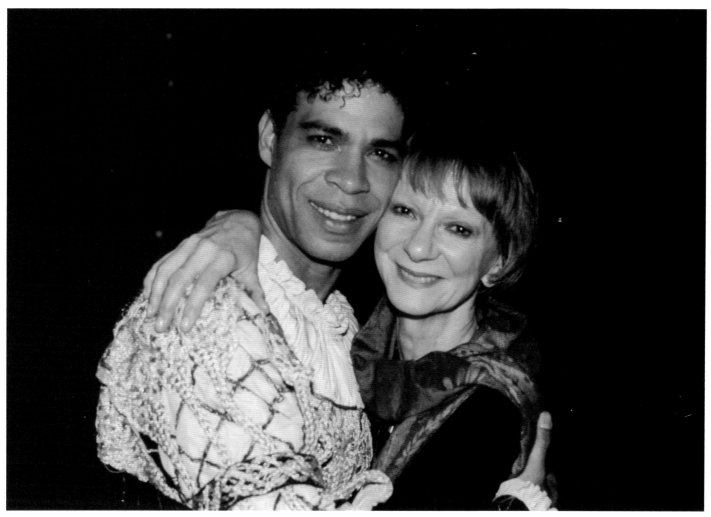

Jeanetta
Laurence
with Carlos
Acosta after a
performance
of *Swan Lake*
Photograph by
Alan Schneider

got a solid gold pedigree and an extraordinary history that I feel so pleased
and privileged to be a part of.'

She is one of the rare few who has worked with all eight of The Royal
Ballet's directors – rehearsing under De Valois, Frederick Ashton and
Kenneth MacMillan, collaborating with Norman Morrice when he headed
the choreographic course at The Royal Ballet School and working on the
management team with Anthony Dowell, Ross Stretton, Monica Mason
and Kevin O'Hare. Over the last quarter of a century, she has witnessed the
evolution of the Company and has been a constant presence through times
of transition as different personalities have taken its helm – 'With each new
director,' says Jeanetta, 'it seems the Company moves on considerably, and I
think the previous one would find the landscape very different.'

Memories of her first years in the Company office at Barons Court, working
with Dowell, are full of fondness, and of respect for the way he led The Royal
Ballet after taking on the challenging role of Director at De Valois's request.
'Having been such a star as a dancer it was a very big shift', she explains.
'Together with Anthony Russell-Roberts, the Administrative Director, he

steered the Company through a very difficult time at the end of the 80s. His integrity and wisdom, combined with a wicked sense of humour, made him a joy to work with. I think with the long hours that we put in you have to have a sense of humour!'

By the time Mason became Director in 2002, Jeanetta was part of the close-knit team at the nucleus of the Company that also included Russell-Roberts and O'Hare, who was then Company Manager. Having known each other since their dancing days, Jeanetta and Monica – who, she says, 'took to directorship like the proverbial duck to water' – worked seamlessly, often continuing to discuss performances long after hours on tube rides home.

As Jeanetta's role grew, she was appointed Mason's Assistant Director in 2003, and then Associate Director in 2009. Her job of recent years encompassed burgeoning responsibilities, tasks and projects relating to every imaginable aspect of the Company's life and work. Each day was unique, and involved anything from assisting the director with important decisions – such as the choice of repertory, and principal casting – to producing board papers and programme notes, providing a point of contact and advice for the dancers or scrutinizing their costumes. And, of course, she almost never missed a performance.

In fact, the workload of The Royal Ballet as a whole has increased significantly as both the Royal Opera House and the Company within it continue to lead in the promotion of ballet as an art form. These days, The Royal Ballet reaches far beyond Covent Garden with huge amounts of media and a host of small projects and education initiatives – all of which must be juggled by the management team.

Although she is retiring in the midst of all this, Jeanetta has no doubt whatsoever that the Company is in safe hands under O'Hare, who took the reins in 2012. 'The remit is bigger than ever, but Kevin is so perfectly equipped to deal with everything that presents itself as the Company evolves', she says. And she is also incredibly excited for what The Royal Ballet will go on to do under his leadership. 'Kevin has an innate ability to programme well', she explains, 'and, with three of the most sought-after choreographers in the world so closely associated with the Company, it's another golden period... the Company right now is at another pinnacle'.

Having stepped back from the day-to-day of management, Jeanetta continues to be involved with many dance-related projects. One of her most important positions is as a trustee of the Ashton Foundation – an organization that owes its existence to her hard work and perseverance. 'I had just got a bit of a bee in my bonnet about the fact that Ashton is the Company's Founder Choreographer and MacMillan and Balanchine, two other choreographic giants... they're very well looked after', explains Jeanetta. So, in 2011, she made the case for a body to perpetuate Ashton's legacy and – with the financial help of some very generous supporters of his work – established the Foundation. Now thriving, it works alongside the rightsholders of Ashton's ballets to protect and promote the works that helped to forge The Royal Ballet's reputation.

Though Jeanetta has overseen her final performance as Associate Director, she doesn't feel that her time with The Royal Ballet is over. 'My plans for the future are to enjoy more of everything else that life has to offer, but of course I think that when you've been involved with this wonderful organization for as long as I have, you don't really leave it', she says. 'We always talk about the Royal Ballet family, and I would extend that to the Royal Opera House, actually. I've known so many people here for so many years, that it really does have that feel.'

Kevin O'Hare might only be semi-serious about needing a red telephone on his desk programmed with Jeanetta's number – but there is no doubt that her presence within The Royal Ballet will endure, through both the work she continues to do for the Company and the incredible legacy she leaves behind.

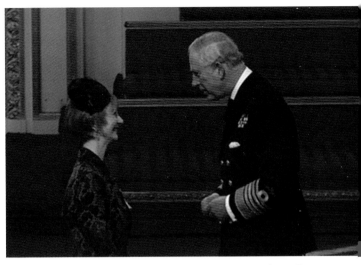

Jeanetta Laurence receives the OBE from HRH Prince Charles
Photography credit: Image courtesy of British Ceremonial Arts Limited

BARRY WORDSWORTH, MUSIC DIRECTOR

At the end of the 2014/15 Season Barry Wordsworth stepped down as Music Director of The Royal Ballet. 'Lucky the company who has the resources that we have', says Barry. 'We can call on one of the world's greatest theatre orchestras and some of the most talented music staff. These are resources that we should nurture.'

And nurture them he has. During his time, he has maintained and extended the very high musical standards for which the Company is internationally renowned, ensuring the refreshment of the musical repertory by supporting the commissioning of new scores and reviving or revisiting old ones, and championed the Company's encouragement and development of young musical and conducting talent.

Barry was first appointed Assistant Conductor to the Company's touring orchestra in 1972 and the following year was made Principal Conductor of Sadler's Wells Royal Ballet (later Birmingham Royal Ballet). He has held the role of Music Director for The Royal Ballet twice: once from 1990 to 1995, and again since 2007.

'I started as a harpsichordist with the Company, with *Las hermanas* in 1971. At that time John Auld, who was then the Company's Assistant Director, came to me and said, "We understand you've done some conducting, would you like to have a go?" And quite by chance it went very well, so they offered me the place as Assistant Conductor to the Touring Company.' As formative experiences go it must have been pretty special. A glance back at castsheets from the mid-1970s sees Wordsworth conducting performances of Ashton's *Cinderella* and MacMillan's *Manon* with Natalia Makarova and Anthony Dowell (Robert Helpmann and Leslie Edwards were Cinderella's step-sisters); performances of MacMillan's *Romeo and Juliet* with Merle Park as Juliet and David Wall or Rudolf Nureyev as Romeo. 'There I was', remembers Barry, 'basically a Baroque church musician, harpsichordist, organist, and suddenly I was thrown into the theatre. It was life-changing for me.'

A talented young musician, Barry had previously been awarded a scholarship to study at Trinity College of Music at the age of 13, and then another to study at the RCM with Adrian Boult.

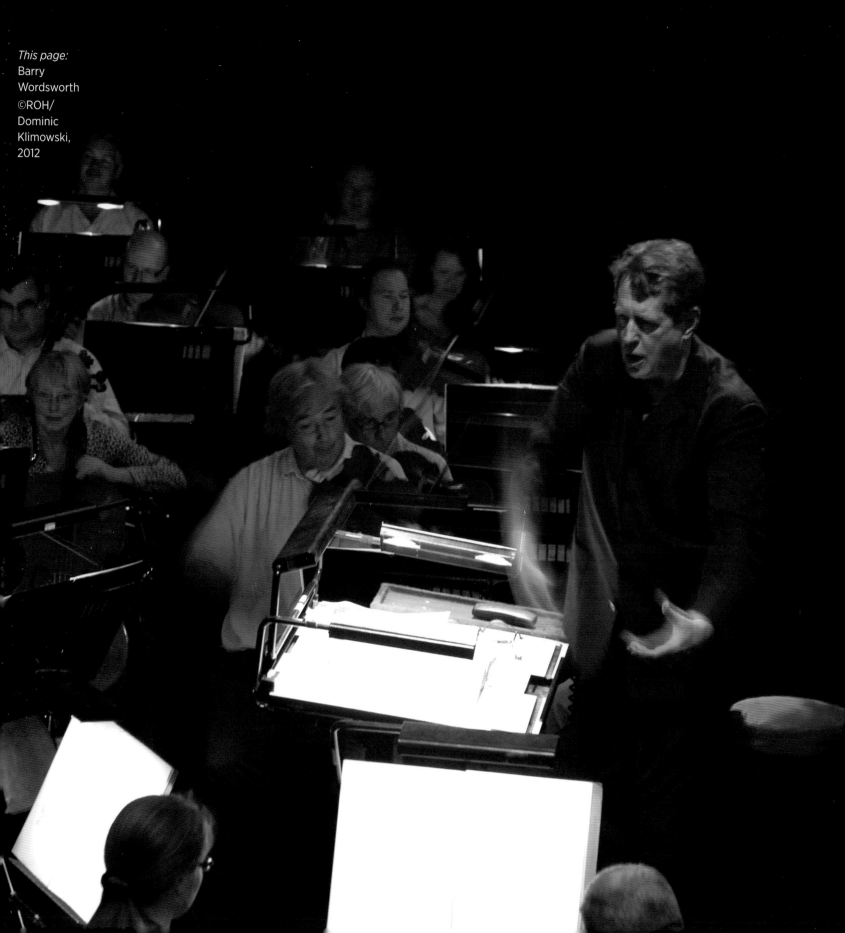

'I remember as a young man', says Barry, 'leaving the Royal College of Music with not the faintest idea of anything to do with ballet. Even if you are a musician studying at college and you have an idea that ballet might be something interesting, where do you go? A company like The Royal Ballet must be prepared to nurture young talent, and I was determined to do what I could, so that musicians could make an informed choice.' Perhaps because of his own route into ballet music, one particularly successful initiative in his time as Music Director has been his enthusiasm for creating the right opportunities for young talent. 'There are always going to be musicians and conductors who prefer to work in the concert hall, but there are very many musicians who just love to work in the theatre. And ballet is above all a theatrical experience.'

He has also made greater use of the exceptionally talented Royal Ballet music staff as performers in their own right. 'I suppose one of my biggest crusades', says Barry, 'has been to keep music for ballet live, not only in performance, but in rehearsal. I'm lucky that Dame Monica and Kevin [O'Hare] have both been extremely supportive in that regard. But also I think The Royal Ballet has always had a distinguished association with its musicians. The music department has always been formidably talented, and it's wonderful when there are pieces that allow those members of staff to shine in a solo capacity. Fortunately there are a lot of pieces in the Royal Ballet repertory that use solo piano.'

Exceptional music has been daily fare for Wordsworth for decades but, he says, it is very difficult to highlight particular pieces. 'I'm very naive and I get very involved in everything I'm doing. At the time I'm doing something, it is always a great event. You can't be so involved and judge at the same time.' It is enough to draw attention to the long heritage of world-class composers whose work has been performed for the Company: 'One of the most interesting sides to a Music Director's job', Wordsworth explains, 'is identifying, preserving and strengthening the link between choreographers and musicians. When you look back at the history of the Company, we have commissioned some of the finest composers – Hans Werner Henze, Benjamin Britten, Arthur Bliss, Ralph Vaughan Williams – the list goes on and on.'

Major contributions to the repertory under Wordsworth include a fresh version of the Britten score for Monica Mason's revival of *The Prince of the Pagodas* and the Joseph Horovitz revisions to the *Giselle* score. He remembers the *Giselle* revisions: 'I had known Joe [Joseph Horowitz] for years, but had not known that he had worked with De Valois at Sadler's Wells. We were talking one evening about the restoration of original scores, and I was nervous about using the original orchestration because I think in a big house like Covent Garden, it sounded a bit thin. Sir Peter Wright's production had originally used the Lanchbery score, but that had absorbed many and various influences. But, talking to Joe, I realized that he knew an amazing amount about ballet music, and about *Giselle* in particular – and he was very keen to work on it. I think he has done a wonderful job. The theatricality of his approach is evident, he's a wonderful craftsman, and his is the version we're still playing.' Wordsworth is thrilled that the Company will revive *Giselle* this Season and that conducting it will be one of his first appointments as Principal Guest Conductor.

Through all his work, as conductor or Music Director, Barry has demonstrated the fundamental role of the ballet conductor as the crucial point of communication between the orchestra and the dancers.

> I think it's very important for the conductor to involve the orchestra as much as possible; to tell them what's going on on stage. In opera you can generally hear what's going on and you're accompanying the singers, which gives you a link. In ballet the only link is the conductor, so if you're not persuasive about what you're doing, and you don't involve the orchestra, you're not going to get a combined ensemble. You need to create an atmosphere where the musicians feel as involved in the ballet as when they're playing for opera.

And, conversely, a ballet conductor must develop a detailed understanding of the way the dancers on stage respond to the music in the pit. 'You can't react *too* quickly to what's happening on stage, you have to preserve the integrity of the music, while at the same time being totally sympathetic to the requirements of the stage. So as ballet conductors we spend a lot of time in the studio, watching the rehearsal process.'

He quotes John Lanchbery, Music Director 1960–72, who said to him: 'In the end, in the performance, neither side should feel they're leading the other. It should be a shared experience that comes to fruition in the performance as a result of all the time spent in the studio.'

And that all-important time spent in the studio, Barry believes, is most useful if the music is played live on the piano by talented pianists who also understand the needs of the dancers both in rehearsal and in performance.

Barry Wordsworth retains his connection with The Royal Ballet, not only in the continuation of what he achieved in his time as Music Director, but with his own return in the role of Principal Guest Conductor. He returns to conduct the two Ashton mixed programmes and again for the revival of *Giselle*. We look forward to his performances during the Season ahead.

KOEN KESSELS

Koen Kessels, Music Director of Birmingham Royal Ballet, succeeds Wordsworth as Music Director of The Royal Ballet. Kessels has been a regular guest conductor with the Company since 2008, conducting many ballets from across the repertory, including *The Nutcracker*, *Giselle* and the world premieres of McGregor's *Raven Girl* in 2013 and Shechter's *Untouchable* in 2015.

RUPERT PENNEFATHER, PRINCIPAL

Principal Rupert Pennefather announced his decision to leave The Royal Ballet after 16 years. During his time with the Company he has danced all of the major classical repertory, with many and varied memorable performances, particularly in Ashton and MacMillan roles, including Beliaev in Ashton's *A Month in the Country*, and Romeo, Des Grieux and Crown Prince Rudolf in MacMillan's *Romeo and Juliet*, *Manon* and *Mayerling*. He also danced in contemporary works including Christopher Wheeldon's *DGV: Danse à grande vitesse* and Wayne McGregor's *Chroma* and created roles for Alexei Ratmansky (*24 Preludes*) and Alastair Marriott (*Sensorium*). Pennefather said,

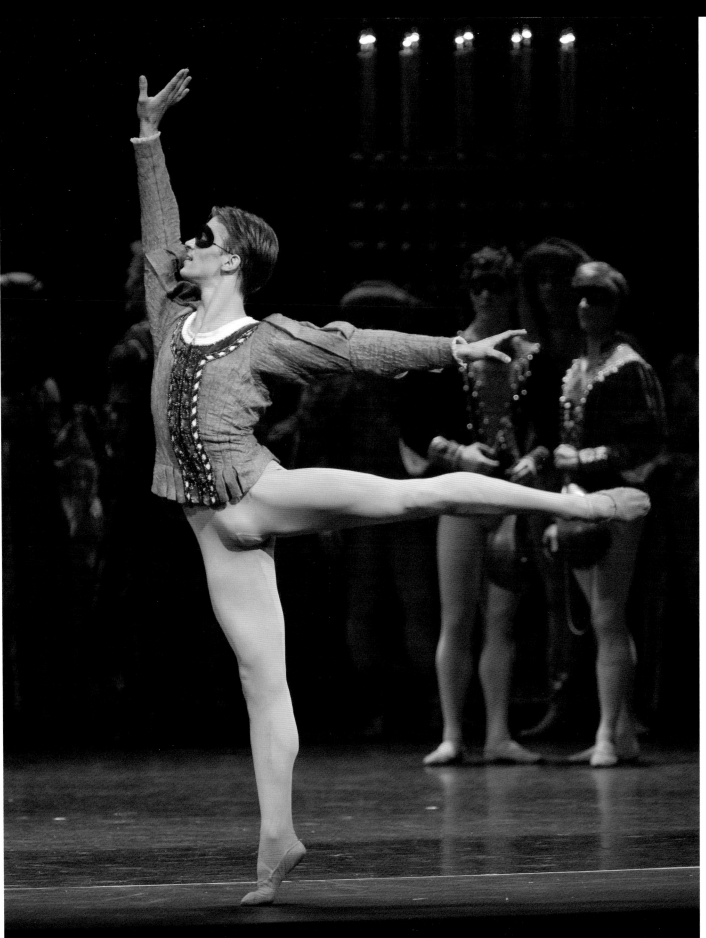

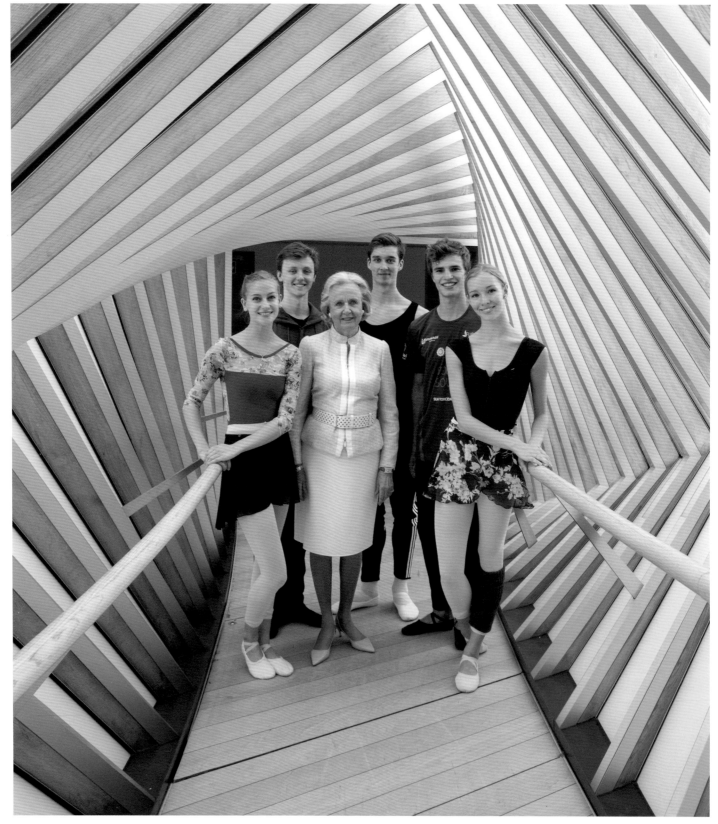

This page:
Aud Jebsen
(centre) with
the 2015/16
Aud Jebsen
Young Dancers,
from left, Julia
Roscoe, Harry
Churches,
Lukas
Bjørnboe
Brændsrød,
Leo Dixon and
Isabel Lubach
©ROH 2015.
Photograph
by Andrej
Uspenski
Opposite page:
Charlotte
Edmonds,
2015/16 Royal
Ballet Young
Choreographer
©ROH 2015.
Photograph
by Andrej
Uspenski

'I'm so grateful for my time with The Royal Ballet. I will always treasure having danced with so many wonderful partners in such incredible productions', and it was time to 'see what other opportunities the future holds'. Kevin O'Hare commented, 'Rupert has been a wonderful dancer with The Royal Ballet, particularly excelling in the dramatic works of Frederick Ashton and Kenneth MacMillan and the fine *danseur noble* roles of the 19th century. We wish him every future success.'

PROMOTIONS AND NEW MEMBERS

For the 2015/16 Season **Francesca Hayward** and **James Hay** are promoted to First Soloists. **Luca Acri**, **Nicol Edmonds**, **Meaghan Grace Hinkis** and **Marcelino Sambé** are promoted to Soloists. **Camille Bracher**, **Mayara Magri**, **Leticia Stock**, **Matthew Ball**, **Sander Blommaert**, **Tomas Mock** and **Donald Thom** are all promoted to First Artists.

Joining the Company as Artists at the start of the Season are **Chisato Katsura** from The Royal Ballet School, **Grace Blundell** (formerly Royal Ballet School), **Ashley Dean** (formerly English National Ballet School), and last Season's Prix de Lausanne dancer **David Yudes. Julian MacKay** joins the Company for the 2015/16 Season as Prix de Lausanne Dancer.

AUD JEBSEN YOUNG DANCERS PROGRAMME

For 2015/16 the Company welcomes five dancers as part of the Aud Jebsen Young Dancers Programme, now in its second Season. The programme provides an opportunity for recently graduated dancers to receive a year's contract to work alongside the corps de ballet of The Royal Ballet. In addition, the dancers are offered mentoring and coaching and have the opportunity to perform with the Company. This Season's Aud Jebsen Young Dancers are Lukas Bjørneboe Brændsrød, Harry Churches, Leo Dixon, Isabel Lubach and Julia Roscoe, all from The Royal Ballet School.

Of the 2014/15 Aud Jebsen Young Dancers, Grace Blundell and Ashley Dean join the Company, Maria Barroso joins The National Ballet of Portugal, Grace Horler joins Scottish Ballet and Ashleigh McKimmie joins Estonian National Ballet.

ROYAL BALLET YOUNG CHOREOGRAPHER PROGRAMME

The Company's nurturing of choreographic talent continues in the 2015/16 Season, with the introduction of the new Royal Ballet Young Choreographer Programme: a 12-month position for an emerging choreographer to shadow both Royal Ballet and visiting choreographers, and utilize Company resources to create work. Charlotte Edmonds, who trained at The Royal Ballet School and at Rambert School of Ballet and Contemporary Dance, will be the first choreographer to participate in the programme. She will be mentored by Director Kevin O'Hare and Resident Choreographer Wayne McGregor. Edmonds created the dance film *The Indifferent Beak* as part of Deloitte Ignite 2014.

OTHER NEWS

First Soloist **Deirdre Chapman** retired from the Company during the 2014/15 Season, with her final performance in Kim Brandstrup's *Ceremony of Innocence*

in November 2014. First Artists **Pietra Mello-Pittman** and **Ludovic Ondiviela** also left the Company. First Artists **Jacqueline Clark**, **Elsa Godard**, **Michael Stojko** and **Andrej Uspenski** left the Company at the end of the Season. For the 2015/16 Season Andrej Uspenski is engaged as a photographer for The Royal Ballet and other departments across the Royal Opera House.

First Soloist **Melissa Hamilton** takes a leave of absence for the 2015/16 Season to spend the year as a principal dancer with the Semperoper Ballett in Dresden.

First Artist **Leanne Cope** continues her sabbatical for the 2015/16 Season, playing Lise Dassin in the Tony Award-winning *An American in Paris*, directed and choreographed by Artistic Associate **Christopher Wheeldon**.

During the 2014/15 Season two Company veterans strongly associated with the formation of The Royal Ballet died.

Derek Rencher died in December, aged 82. He joined the Sadler's Wells Ballet in 1952, was promoted to Soloist in 1957 and Principal in 1969. He later became a Guest Principal Character Artist and danced his last Season with the Company in 1997/8. Rencher created such roles as Paris in MacMillan's *Romeo and Juliet* (1965), Edward Elgar in Ashton's *Enigma Variations* (1968) and Monsieur G.M. in MacMillan's *Manon* (1974). As a character artist he danced roles including Von Rothbart (*Swan Lake*), Kostcheï (*Firebird*) and High Brahmin (*La Bayadère*).

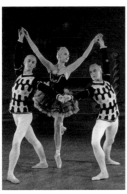

John Hart, who died in February aged 93, joined the Vic-Wells Ballet in 1938, danced lead roles by the time he was 21 and was made a Principal after World War II. He created roles in works by De Valois (*The Prospect Before Us*, 1940) and Ashton (*Sylvia,* 1952, and *Homage to the Queen*, 1953). He became a ballet master in 1955 and was Assistant Director of the Company from 1962–70. He moved to the US and was Artistic Director of Ballet West, Salt Lake City, from 1986–97. He was made a CBE in 1971.

Opposite page: Claire Calvert and Eric Underwood in Charlotte Edmonds's *The Indifferent Beak* ©ROH/ Ruairi Watson, 2014

This page: *Top:* Derek Rencher ©ROH Collections. Photograph by Donald Southern *Below:* Kenneth Macmillan, Beryl Grey, and John Hart in Ballet Imperial ©ROH Collections. Photograph by Roger Wood

THE 2015/16 SEASON AT A GLANCE

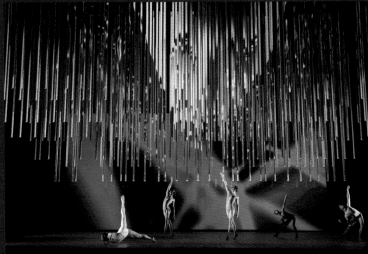

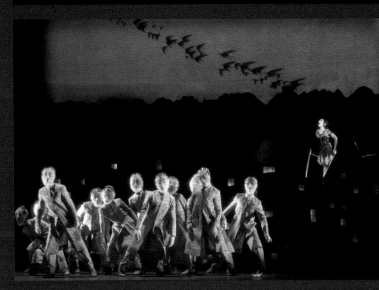

This page:
Artists of The Royal Ballet in *Connectome* ©ROH/Bill Cooper, 2014

Melissa Hamilton in *Raven Girl* ©ROH/Johan Persson, 2013

Marianela Nuñez and Ryoichi Hirano in *Viscera* ©ROH/Andrej Uspenski, 2012

Opposite page:
Artists of The Royal Ballet in *The Winter's Tale* ©ROH/Johan Persson, 2014

Sarah Lamb and Steven McRae in *Giselle* ©ROH/Bill Cooper, 2014

Gary Avis in *The Nutcracker* ©ROH/Bill Cooper, 2012

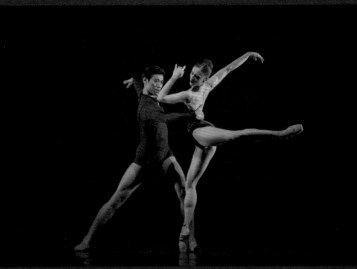

ROMEO AND JULIET
Choreography
Kenneth MacMillan
Music Sergey Prokofiev

Designs Nicholas Georgiadis
Lighting design John B. Read
Conductor Koen Kessels

Premiere
9 February 1965
(The Royal Ballet)

CONNECTOME
Choreography Alastair Marriott
Assistant to the Choreographer
Jonathan Howells
Music Arvo Pärt

Conductor Koen Kessels
Set designs Es Devlin
Costume designs
Jonathan Howells
Lighting design Bruno Poet
Video designs Luke Halls

Premiere
31 May 2014
(The Royal Ballet)

RAVEN GIRL
A new fairytale by
Audrey Niffenegger
Adapted, directed and choreographed for the stage by
Wayne McGregor
Music Gabriel Yared

Conductor Koen Kessels
Designs Vicki Mortimer
Lighting designs Lucy Carter
Film design Ravi Deepres
Associate lighting design
Simon Bennison

Premiere
24 May 2013
(The Royal Ballet)

VISCERA
Choreography Liam Scarlett
Music Lowell Liebermann

Costume designs Liam Scarlett
Lighting design John Hall

Premieres
6 January 2012
(Miami City Ballet)

3 November 2012
(The Royal Ballet)

AFTERNOON OF A FAUN
Choreography Jerome Robbins
Music Claude Debussy

Costume designs Irene Sharraff
Set design and original lighting design Jean Rosenthal
Lighting designs recreated by
Les Dickert

Premieres
14 May 1953
(New York City Ballet)

14 December 1971
(The Royal Ballet)

TCHAIKOVSKY PAS DE DEUX
Choreography
George Balanchine
Music Pytor Il'yich Tchaikovsky

Costume designs
Anthony Dowell
Lighting design John B. Read

Premieres
29 March 1960
(New York City Ballet)

16 March 1964
(The Royal Ballet)

CARMEN (NEW)
Choreography Carlos Acosta
Music Georges Bizet
arranged by Martin Yates

Designs Tim Hatley
Lighting design Peter Mumford

Premiere
26 October 2015
(The Royal Ballet)

MONOTONES I AND II
Choreography
Frederick Ashton
Music Erik Satie

Designs Frederick Ashton
Lighting design John B. Read

Premiere
25 April 1966
(The Royal Ballet)

THE TWO PIGEONS
Choreography Frederick Ashton
Music André Messager
arranged by John Lanchbery

Set and costume designs
Jacques Dupont

Premiere
14 February 1961
(The Royal Ballet)

THE NUTCRACKER

Choreography Peter Wright
after Lev Ivanov
Music Pytor Il'yich Tchaikovksy

Conductor Boris Gruzin
Original Scenario Marius
Petipa after E.T.A Hoffmann's
Nussknacker und Mausekönig
Production and scenario Peter
Wright
Designs Julia Trevelyan Oman
Lighting design
Mark Henderson
Production Consultant
Roland John Wiley

Premieres
16 December 1882
(Mariinsky Theatre,
St. Petersburg)

20 December 1984
(The Royal Ballet,
this production)

ELIZABETH

LINBURY STUDIO THEATRE
Director and Choreography
Will Tuckett
Co-director and text
Alasdair Middleton
Music Martin Yates

Costume designs Fay Fullerton
Lighting design
Simon Bennison
Assistant choreographer
Emma Brunton

Premieres
27 November 2013
(Painted Hall, Old Naval
College, Greenwich)

8 January 2016
(The Royal Ballet)

RHAPSODY

Choreography Frederick Ashton
Music Sergey Rachmaninoff

Conductor Barry Wordsworth
Set designs Frederick Ashton
Original costume designs
William Chappell
Lighting design Peter Teigen

Premiere
4 August 1980
(The Royal Ballet)

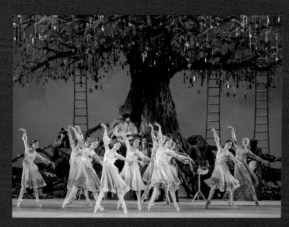

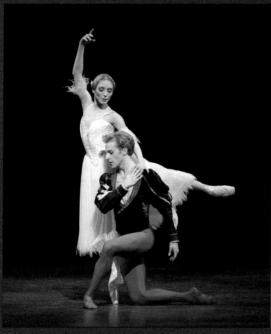

AFTER THE RAIN

Choreography
Christopher Wheeldon
Music Arvo Pärt
Costume designs Holly Hynes
Lighting design Mark Stanley

Premieres
22 January 2005
(New York City Ballet)

12 February 2016
(The Royal Ballet)

NEW CHRISTOPHER WHEELDON

Choreography
Christopher Wheeldon
Music Mark-Anthony Turnage

Conductor Koen Kessels
Designs Bob Crowley
Lighting design
Natasha Chivers
Scenario Charlotte Westenra

Premiere
12 February 2016
(The Royal Ballet)

WITHIN THE GOLDEN HOUR

Choreography
Christopher Wheeldon
Music Ezio Bosso

Designs Martin Pakledinaz
Lighting design James F. Ingalls

Premieres
22 April 2008
(San Francisco Ballet)

12 February 2016
(The Royal Ballet)

GISELLE

Music Adolphe Adam
revised by Joseph Horovitz
Choreography Marius Petipa
after Jean Corelli *and* Jules
Perrot

Scenario Théophle Gautier
after Heinrich Heine
Conductor Barry Wordsworth
*Production and additional
choreography*
Peter Wright
Designs John Macfarlane
Original lighting Jennifer Tipton
recreated by David Finn

Premieres
28 June 1841
(Paris: Original choreography
by Jean Corelli and Jules
Perrot; Later versions
by Petipa, notably 1884)

1 January 1934
(Vic-Wells Ballet)

28 November 1985
(The Royal Ballet, this
production)

THE WINTER'S TALE

Choreography
Christopher Wheeldon
Music Joby Talbot

Conductor David Briskin and
Tom Seligman
Designs Bob Crowley
Lighting design Natasha Katz
Projection design Daniel Brodie
Silk effects design Basil Twist

Premiere
10 April 2014
(The Royal Ballet)

FRANKENSTEIN

Choreography Liam Scarlett
Music Lowell Liebermann

Conductor Koen Kessels and
Tom Seligman
Designs John Macfarlane
Lighting design David Finn

Premiere
4 May 2016
(The Royal Ballet)

NEW WAYNE MCGREGOR

Choreography
Wayne McGregor
Music Esa-Pekka Salonen

Conductor Esa-Pekka Salonen
and Tim Murray
Lighting design Lucy Carter

Premiere
28 May 2016
(The Royal Ballet)

THE INVITATION

Choreography
Kenneth MacMillan
Music Mátyás Seiber

Conductor Tim Murray
Set and costume designs
Nicholas Georgiadis
Lighting design
Michael Northen
Revival lighting design
John B. Read

Premiere
10 November 1960
(The Royal Ballet)

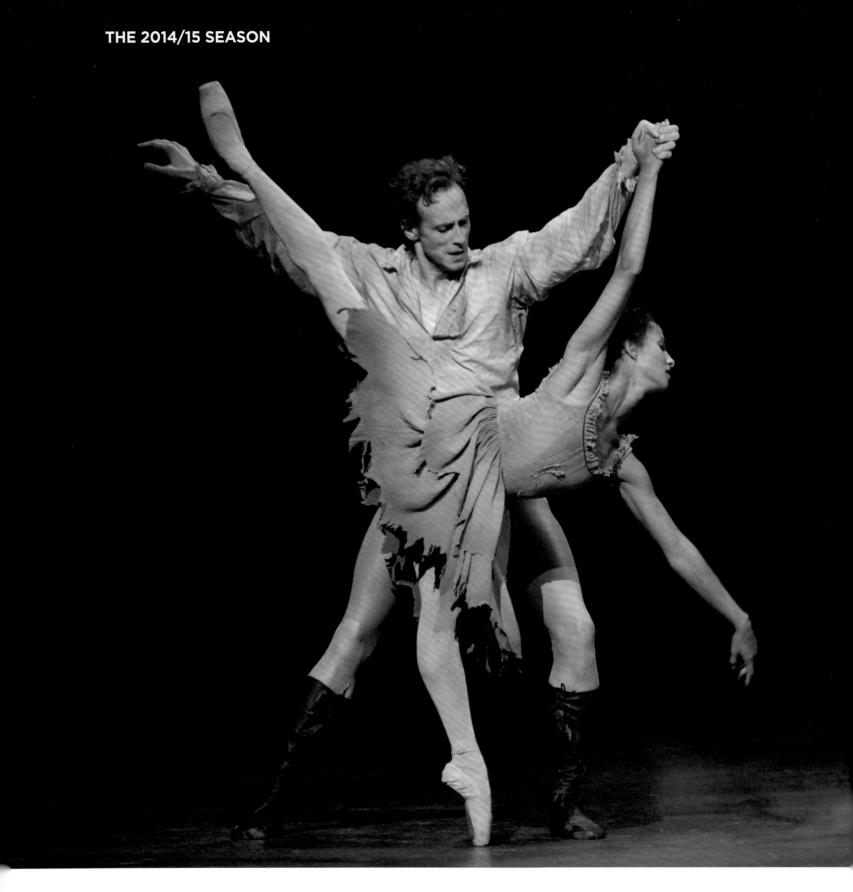

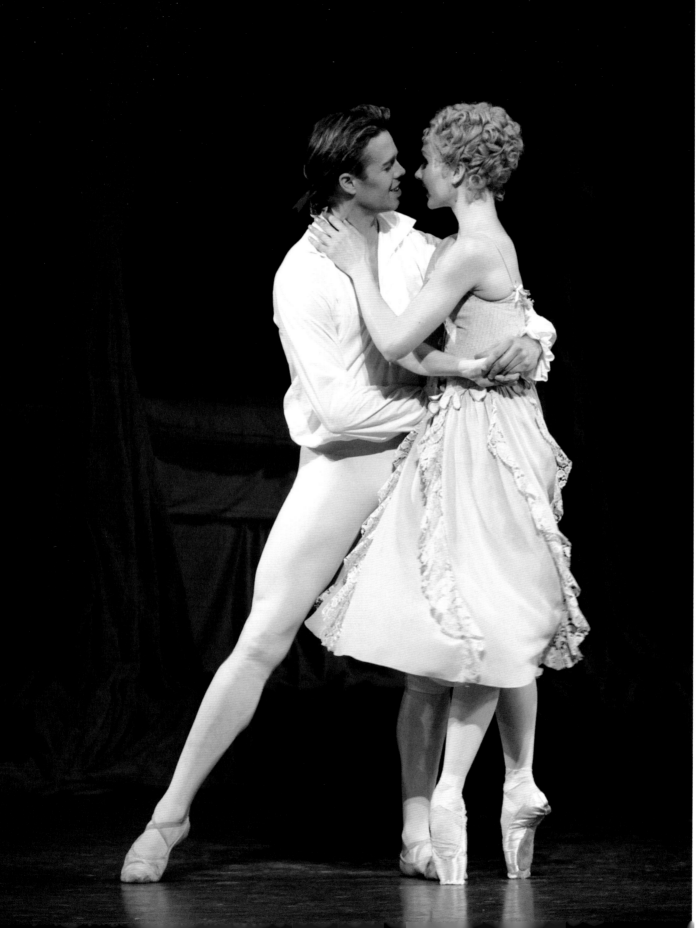

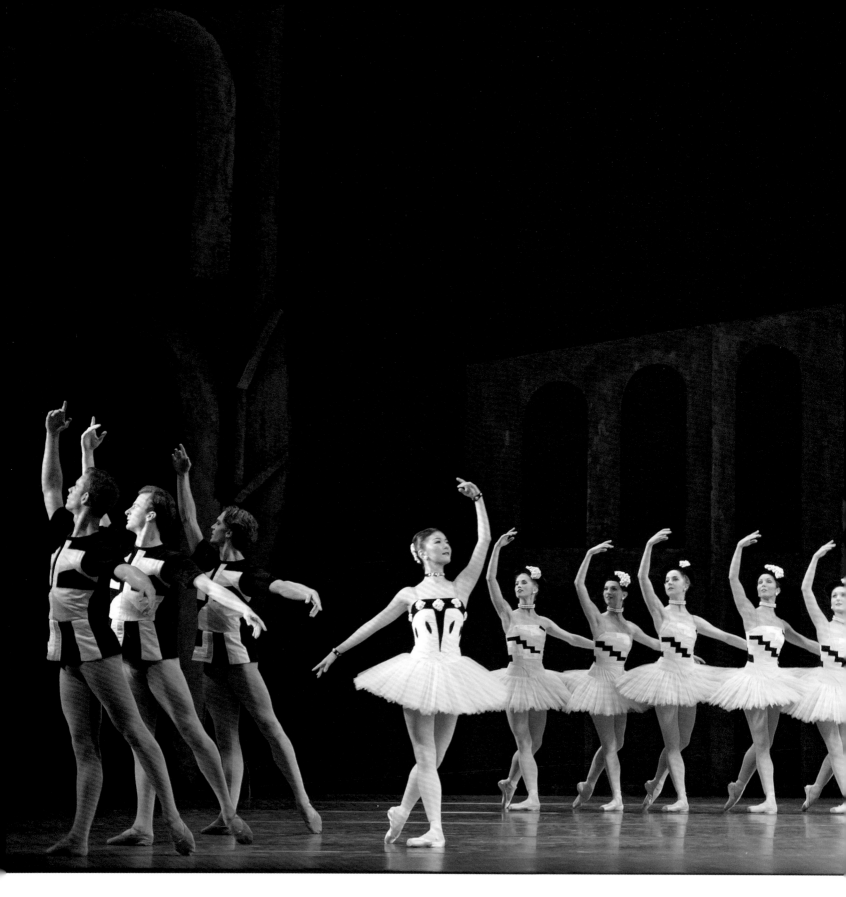

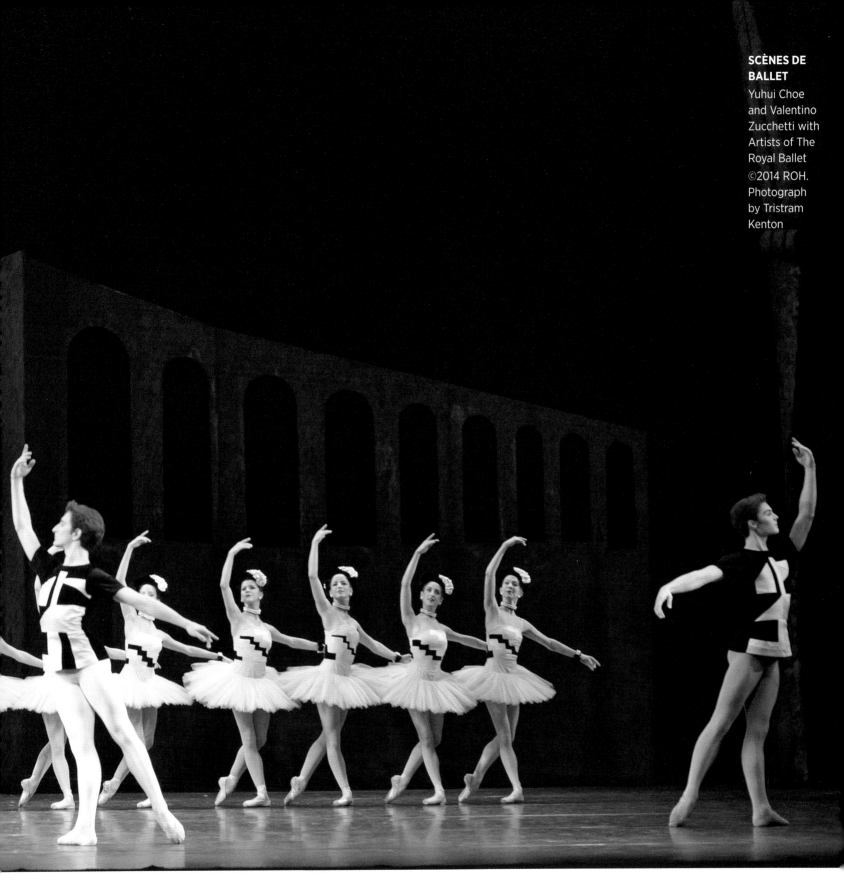

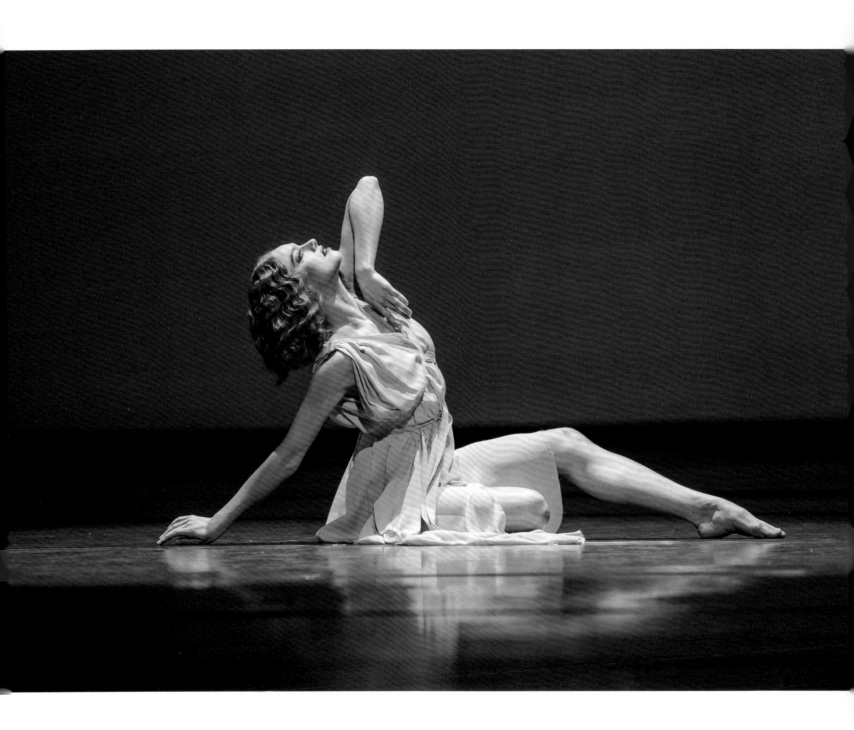

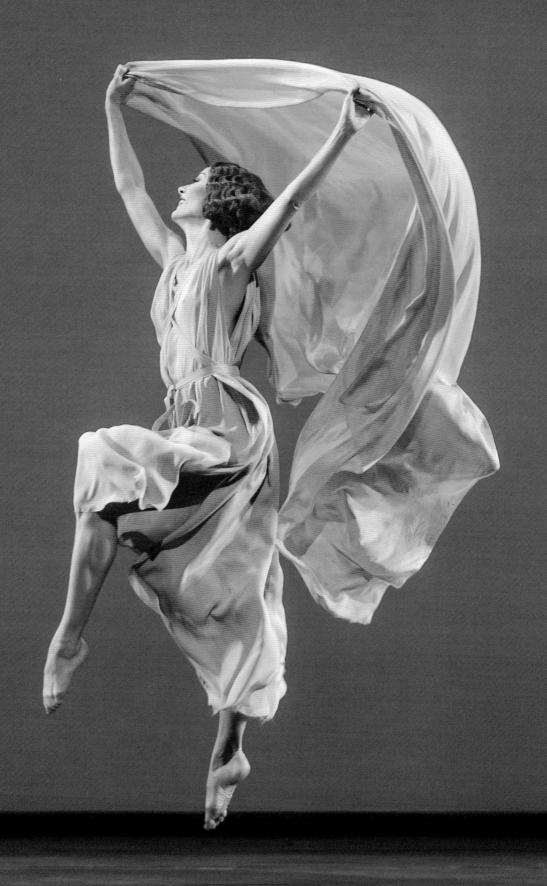

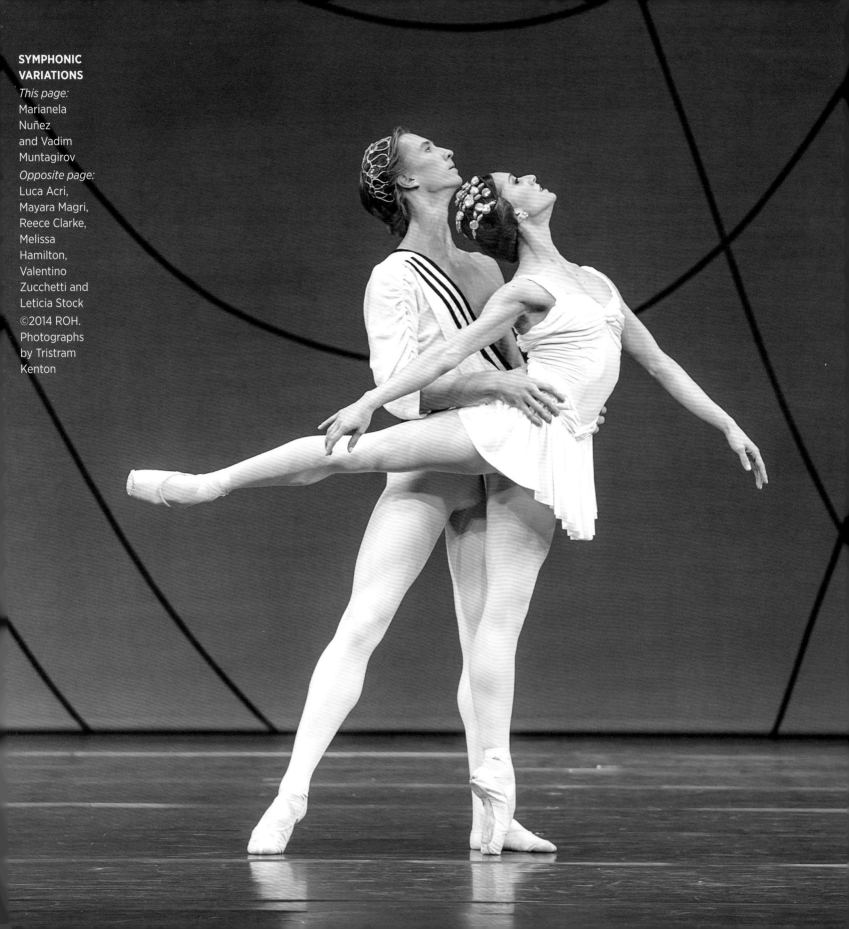

SYMPHONIC VARIATIONS

This page: Marianela Nuñez and Vadim Muntagirov

Opposite page: Luca Acri, Mayara Magri, Reece Clarke, Melissa Hamilton, Valentino Zucchetti and Leticia Stock ©2014 ROH. Photographs by Tristram Kenton

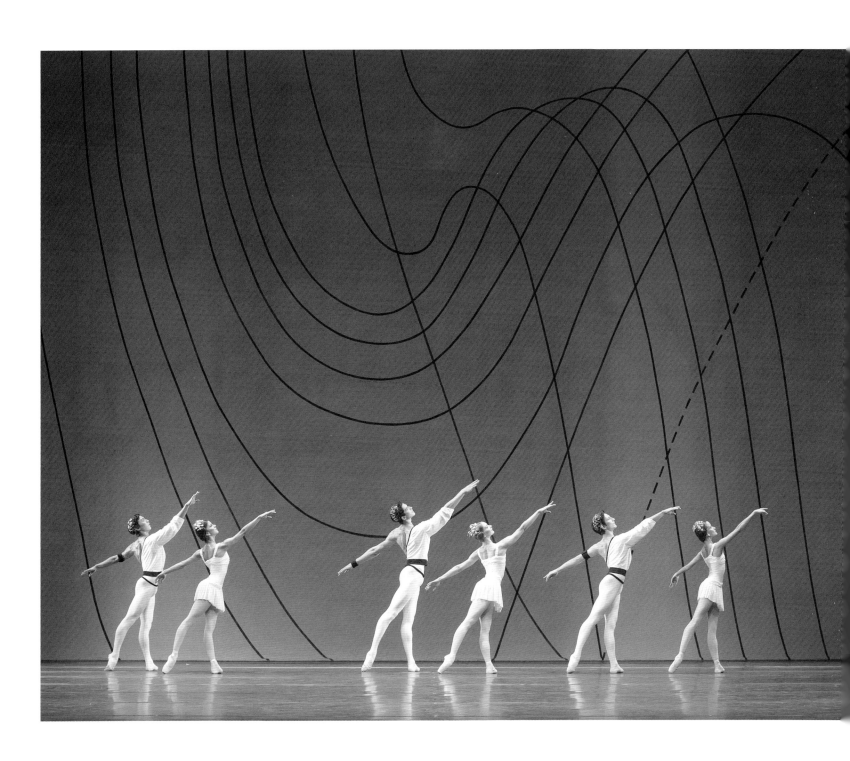

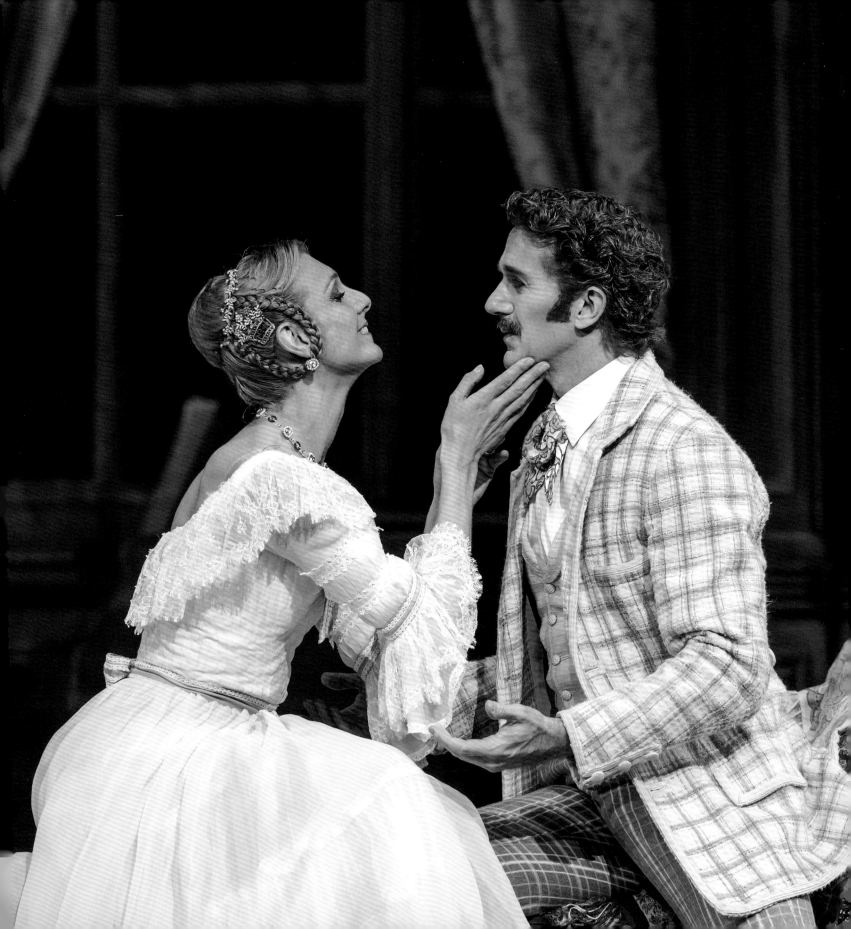

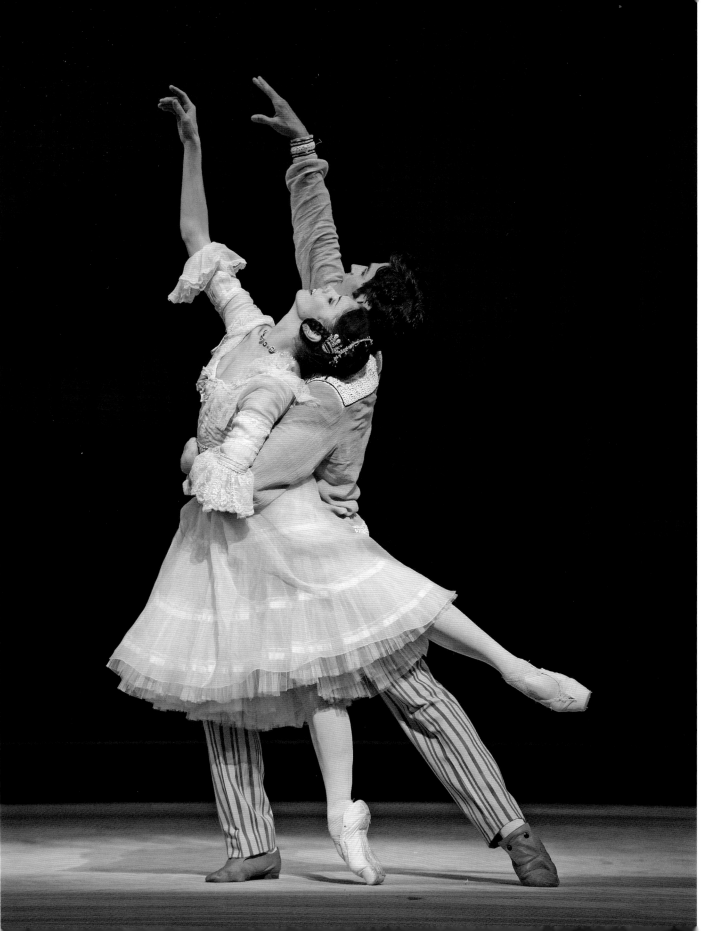

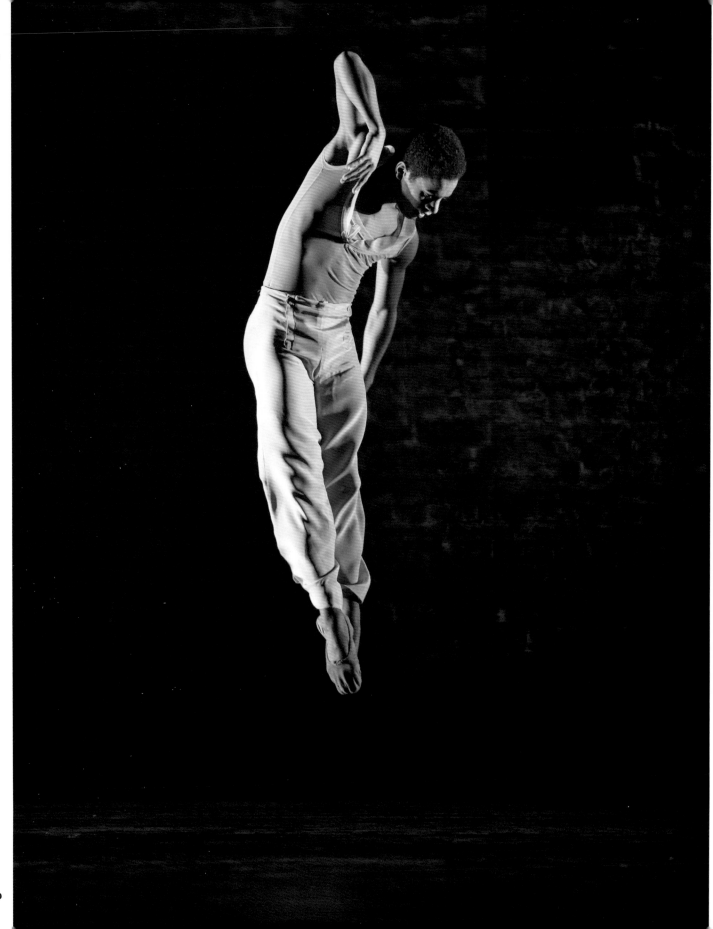

CEREMONY OF INNOCENCE

This page: Marcelino Sambé

Opposite page: Christina Arestis and Edward Watson

©2014 ROH. Photographs by Bill Cooper

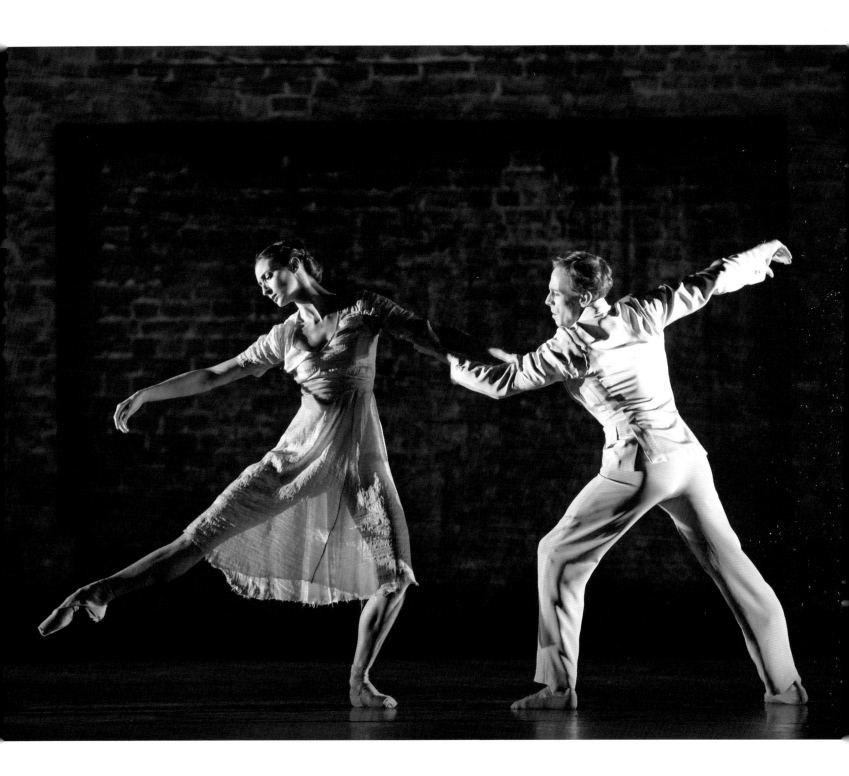

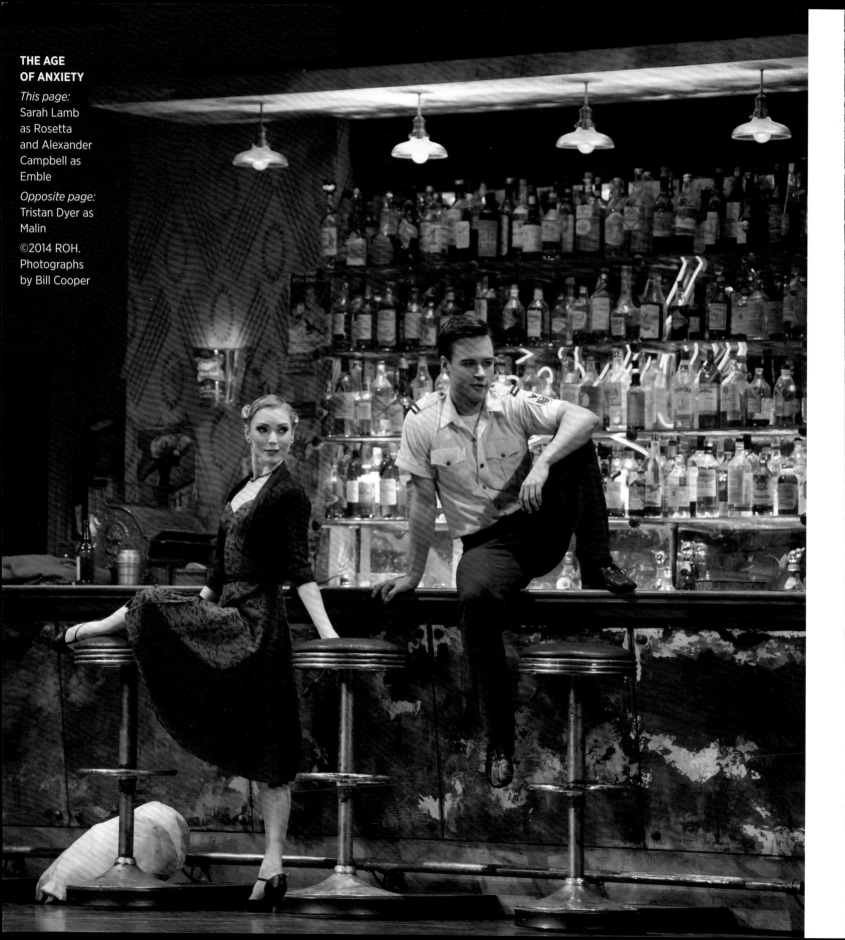

**THE AGE
OF ANXIETY**

This page:
Sarah Lamb
as Rosetta
and Alexander
Campbell as
Emble

Opposite page:
Tristan Dyer as
Malin

©2014 ROH.
Photographs
by Bill Cooper

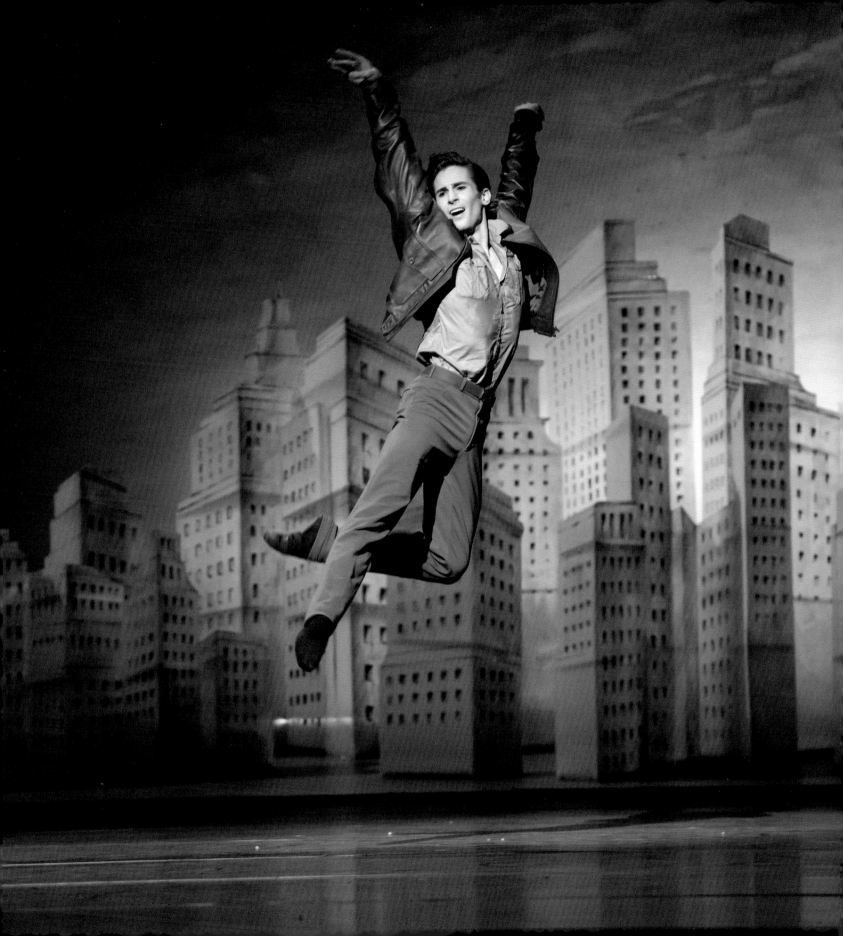

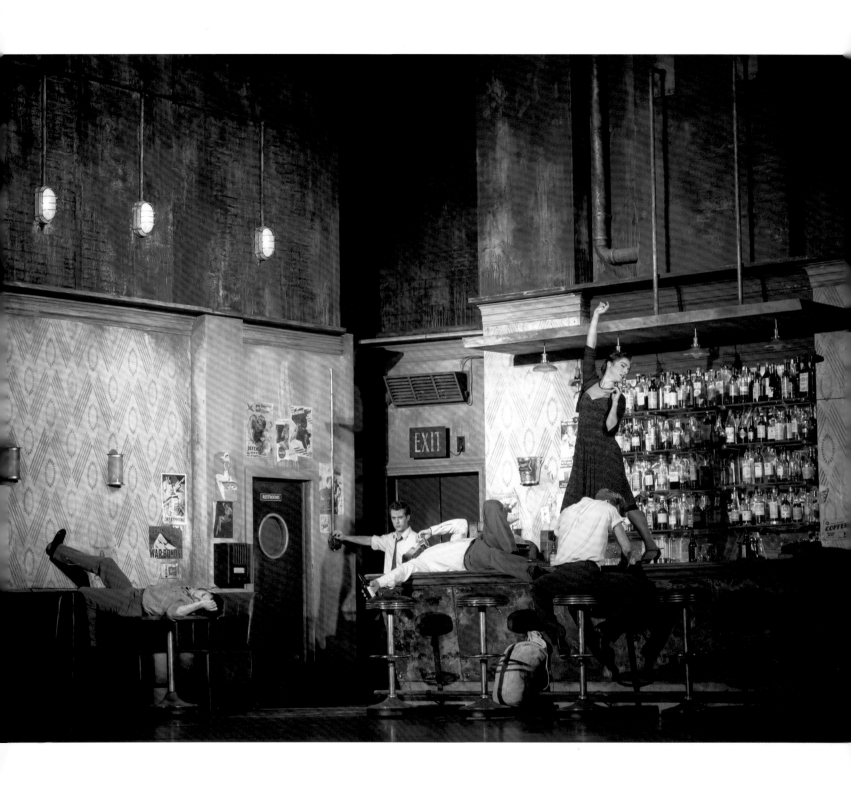

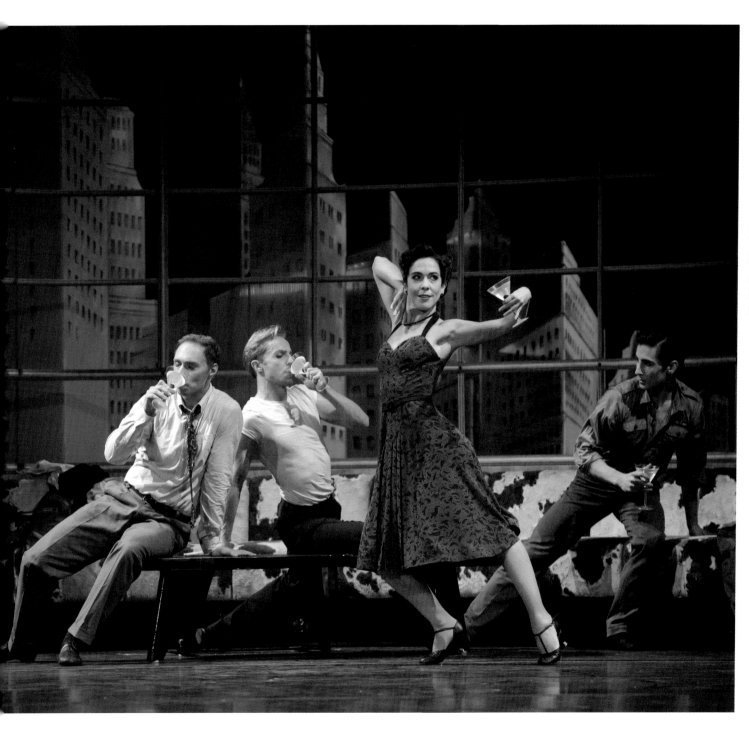

Opposite page:
Laura Morera
as Rosetta and
Kevin Emerton
as Bartender

This page:
Bennet
Gartside as
Quant, Steven
McRae as
Emble, Laura
Morera as
Rosetta and
Tristan Dyer as
Malin

©2014 ROH.
Photographs
by Bill Cooper

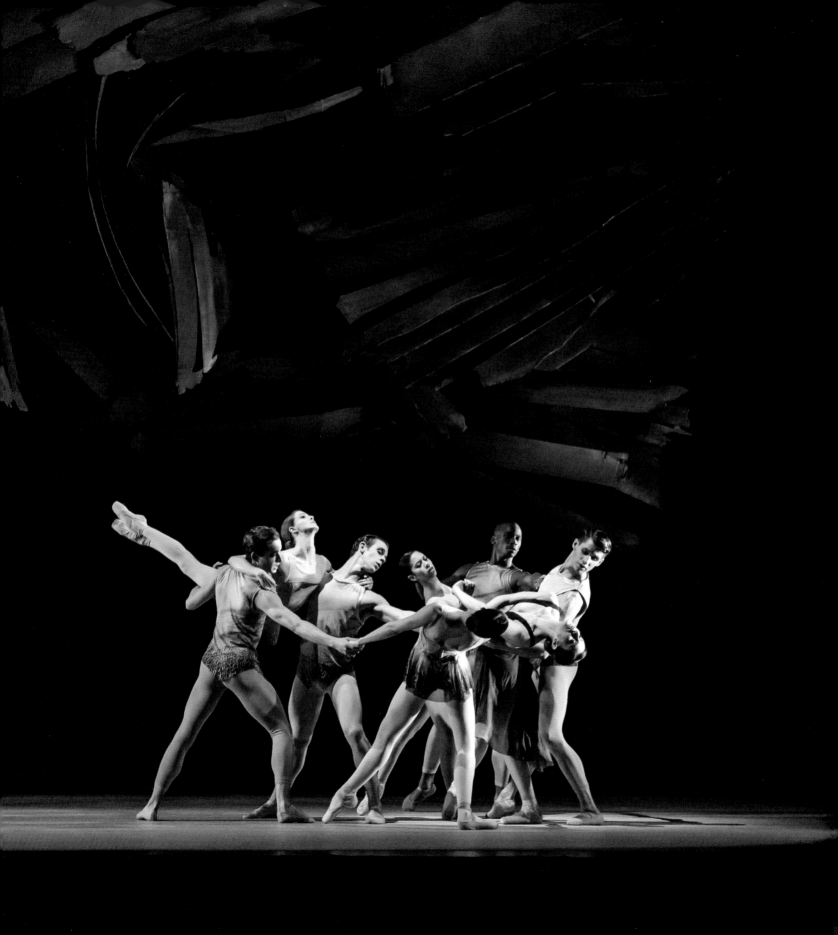

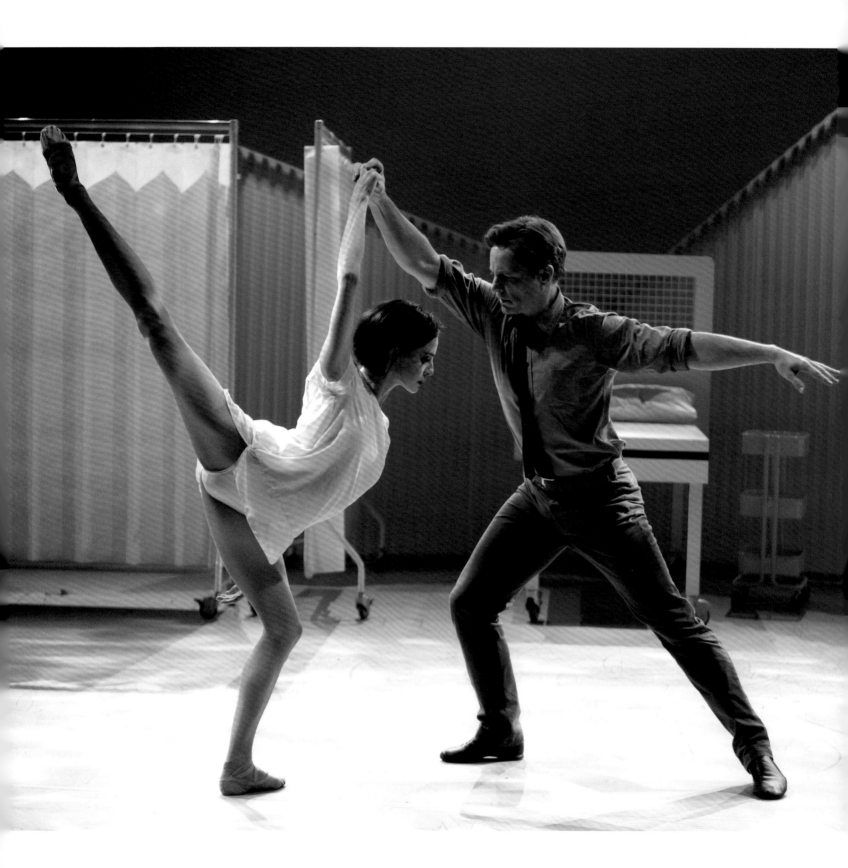

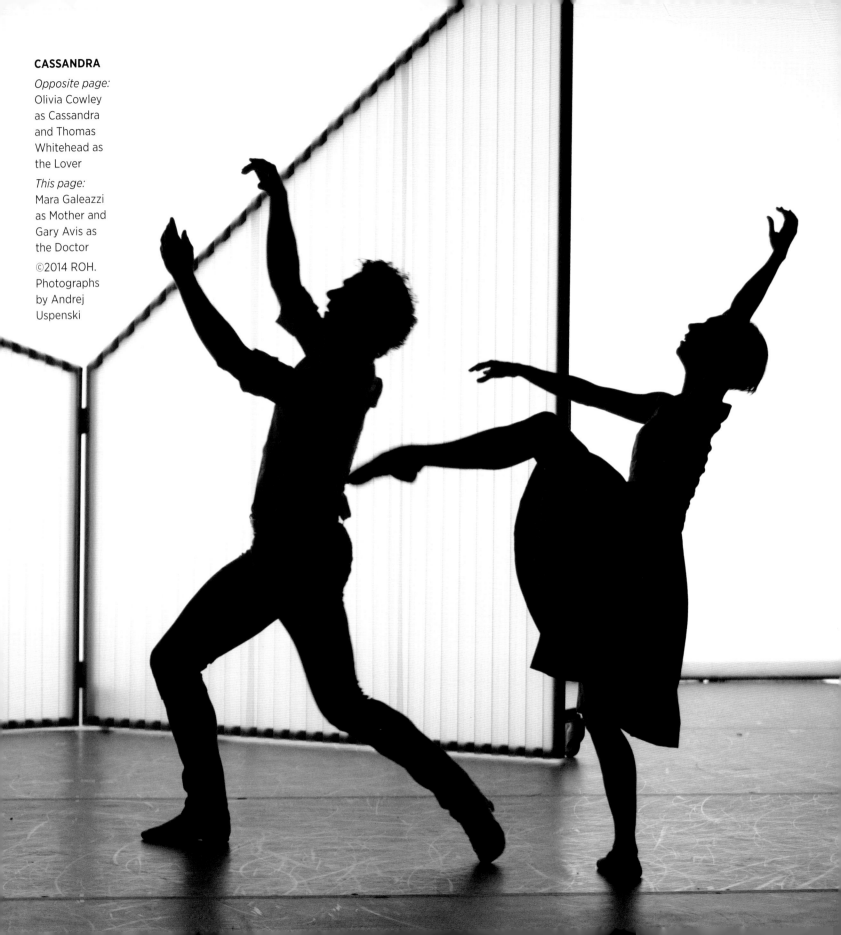

CASSANDRA

Opposite page:
Olivia Cowley
as Cassandra
and Thomas
Whitehead as
the Lover

This page:
Mara Galeazzi
as Mother and
Gary Avis as
the Doctor

©2014 ROH.
Photographs
by Andrej
Uspenski

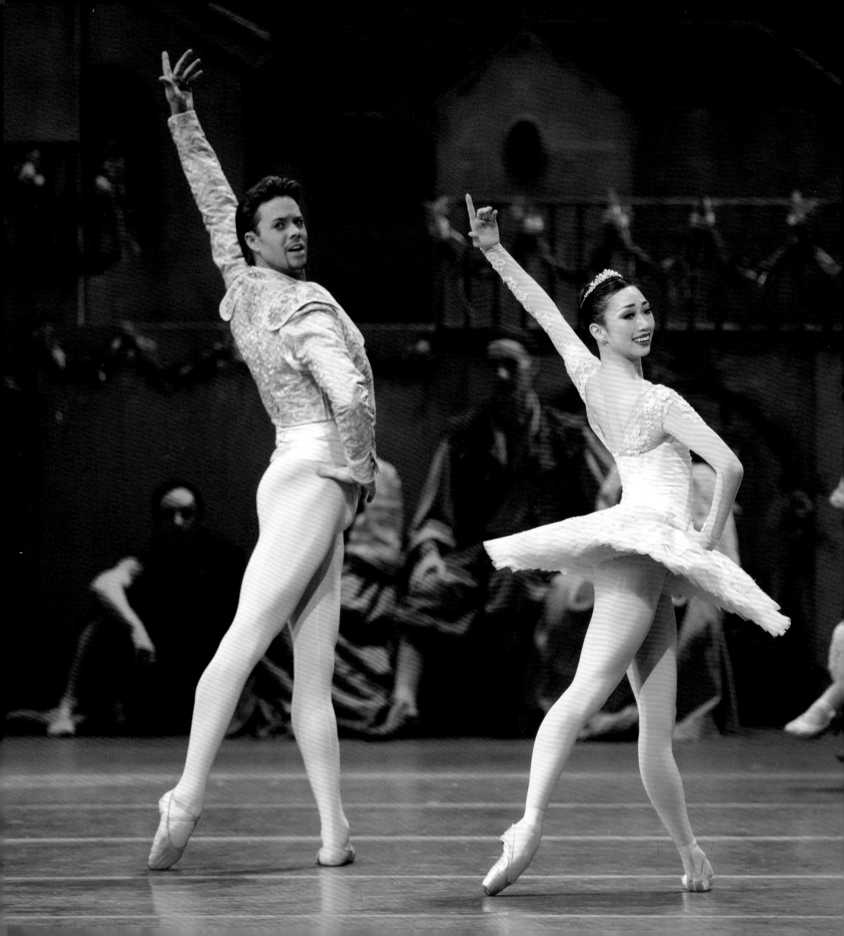

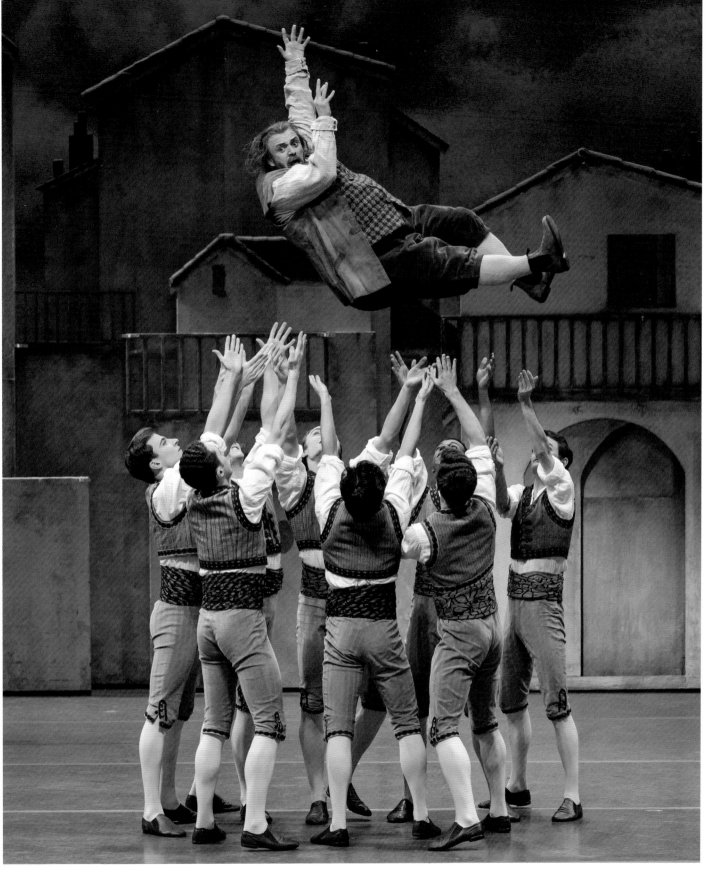

DON QUIXOTE

Opposite page:
Akane Takada as Kitri and Matthew Golding as Basilio

This page:
Philip Mosley as Sancho Panza and Artists of The Royal Ballet

©2014 ROH. Photographs by Bill Cooper

This page:
Francesca
Hayward
as Alice

Opposite page:
Donald Thom
as the Mad
Hatter

©2014 ROH.
Photographs
by Bill Cooper

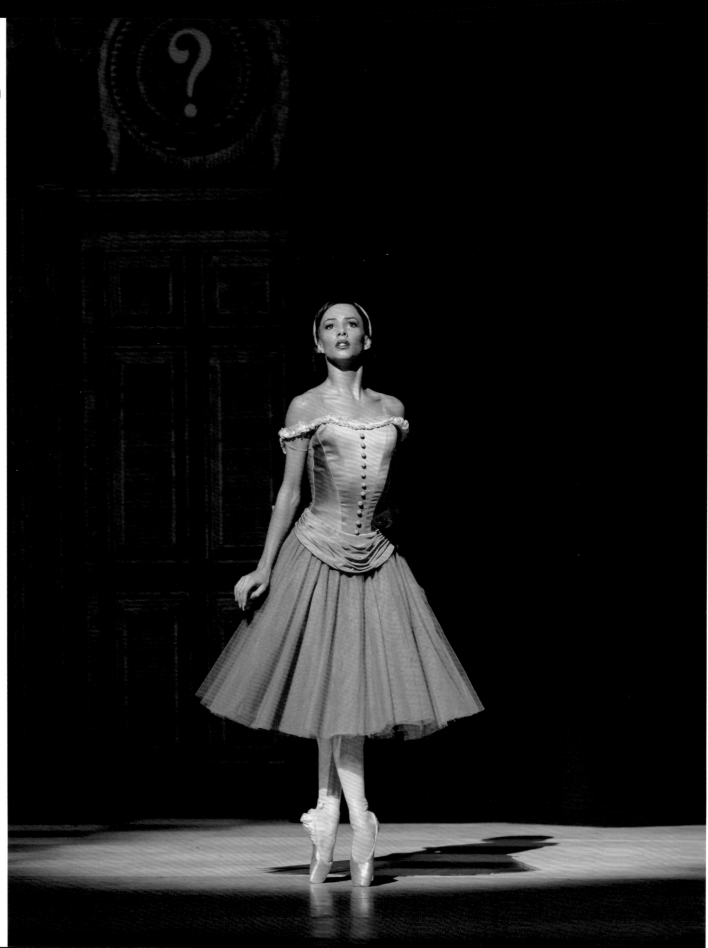

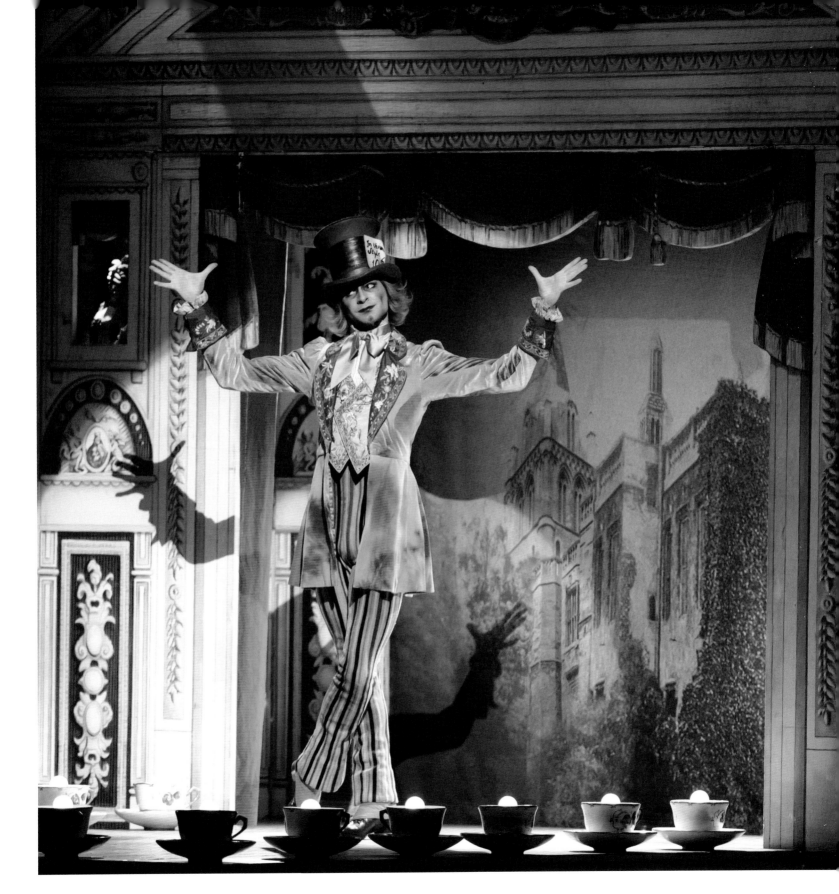

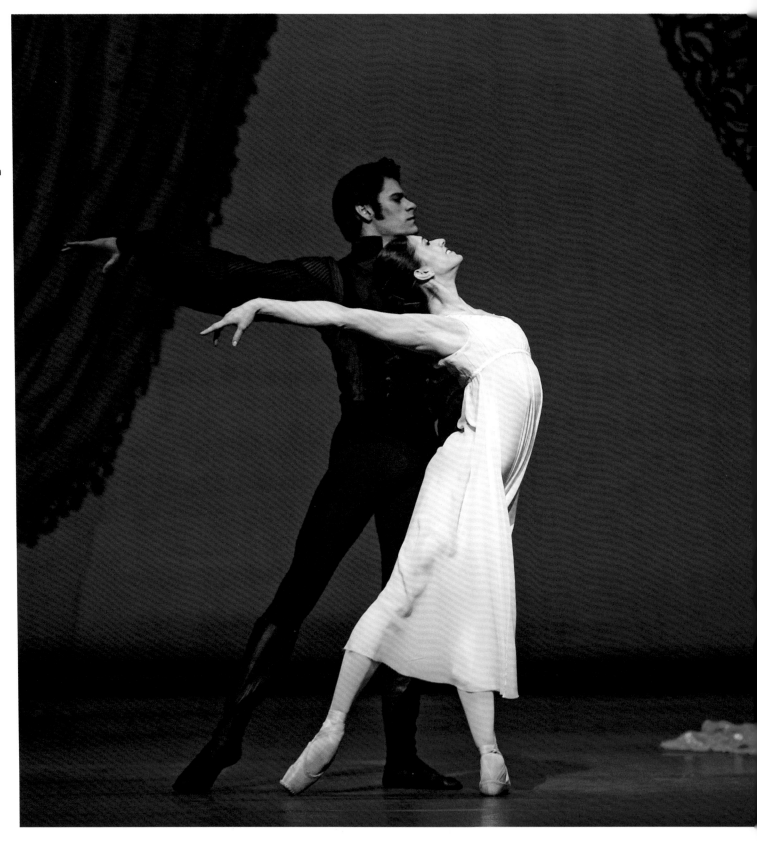

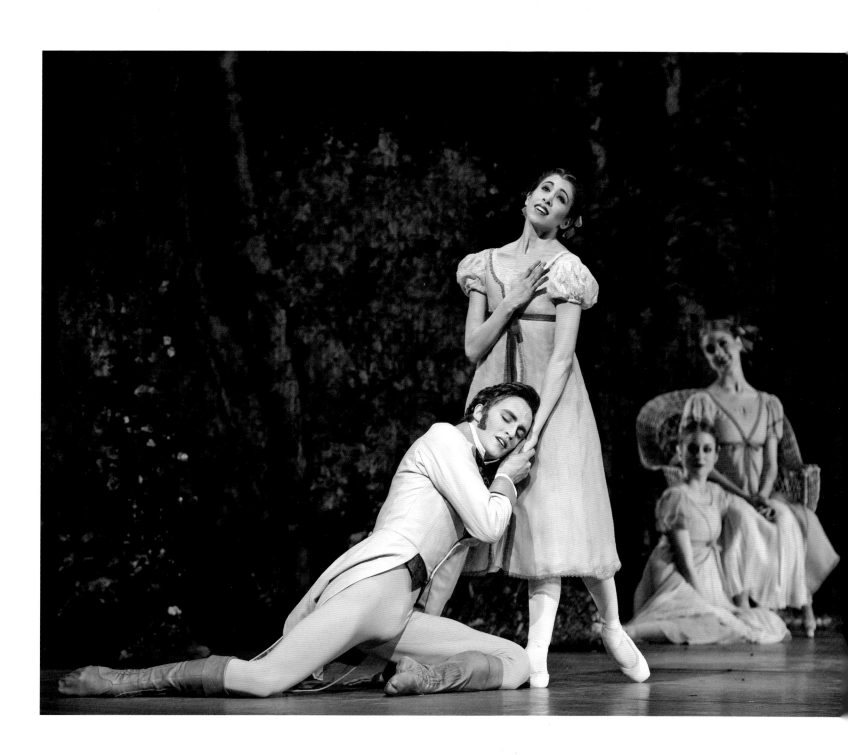

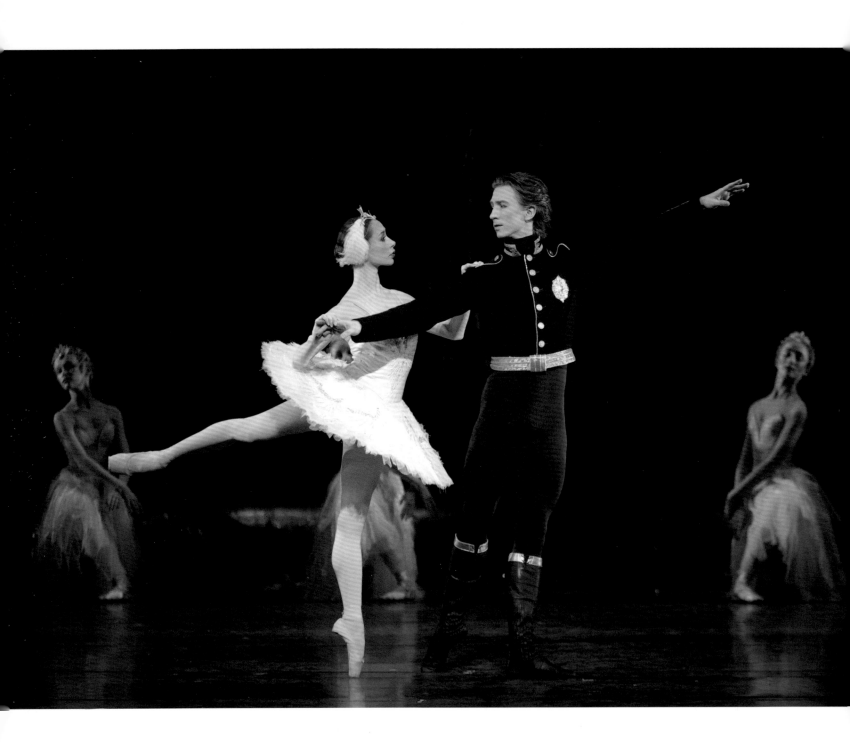

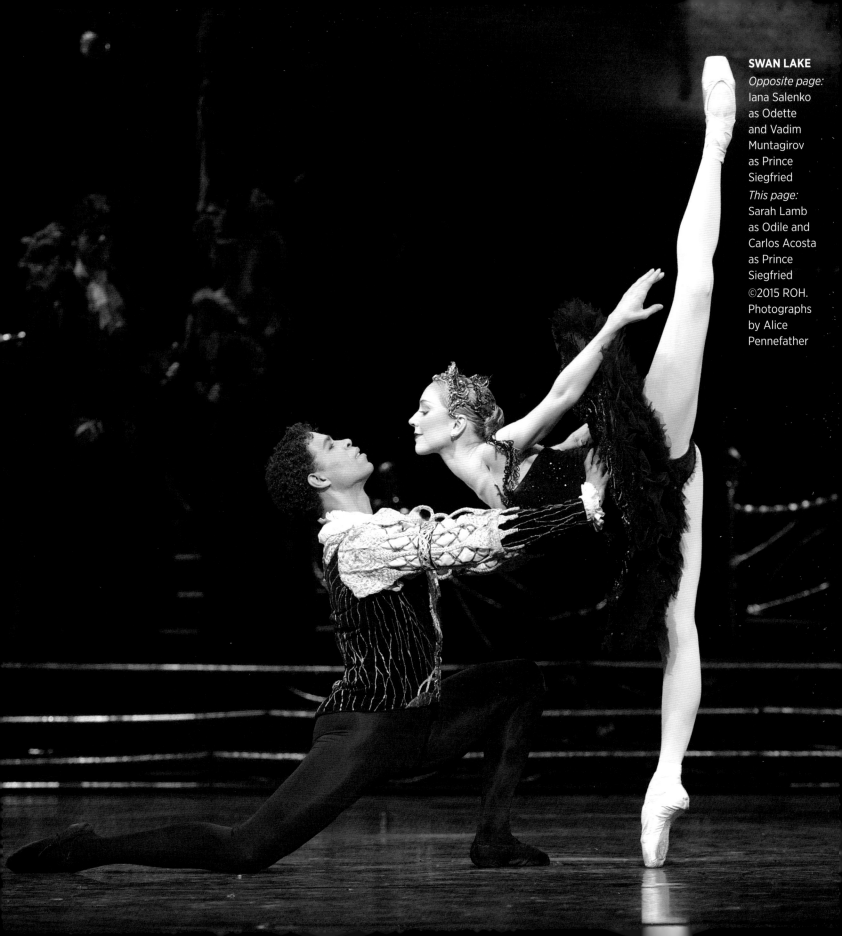

SWAN LAKE
Opposite page: Iana Salenko as Odette and Vadim Muntagirov as Prince Siegfried
This page: Sarah Lamb as Odile and Carlos Acosta as Prince Siegfried
©2015 ROH. Photographs by Alice Pennefather

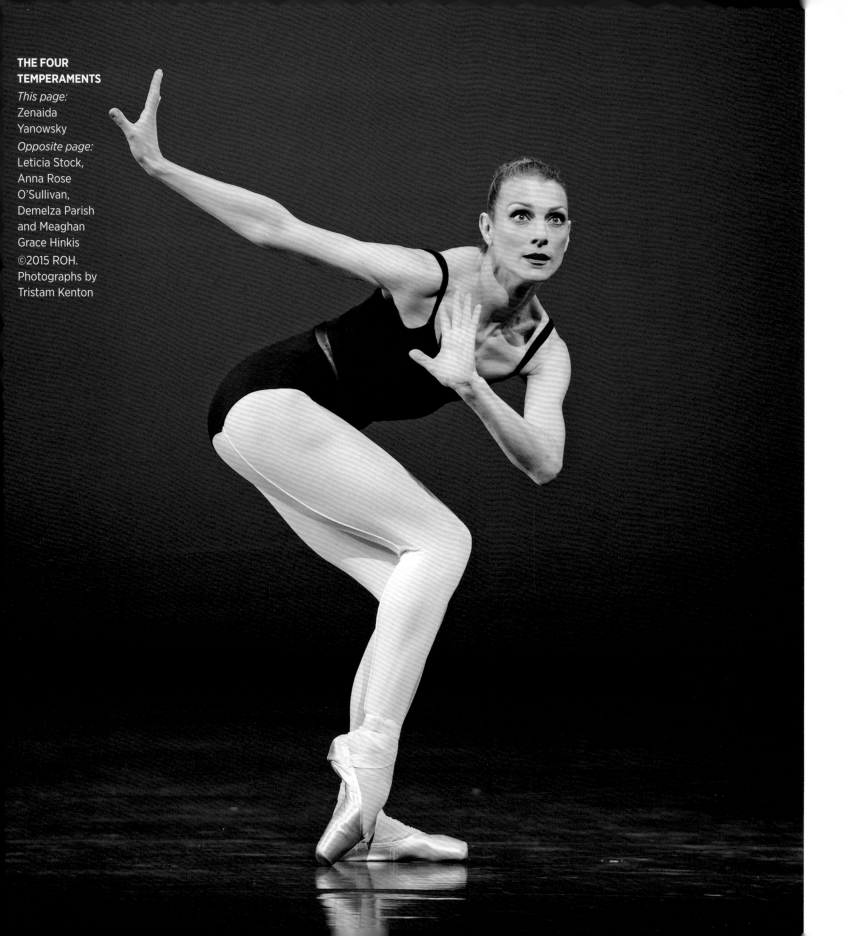

THE FOUR TEMPERAMENTS
This page: Zenaida Yanowsky
Opposite page: Leticia Stock, Anna Rose O'Sullivan, Demelza Parish and Meaghan Grace Hinkis
©2015 ROH. Photographs by Tristam Kenton

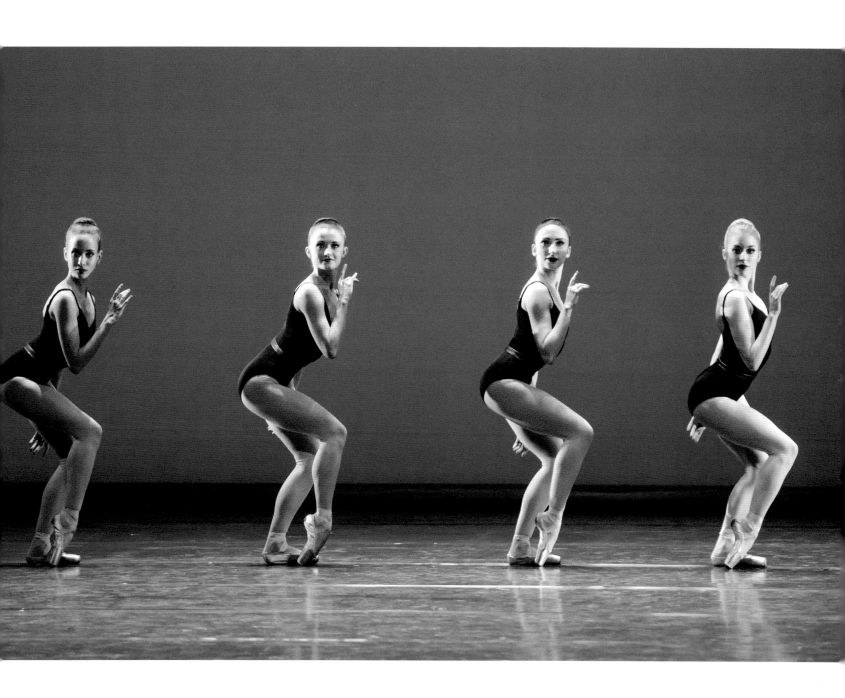

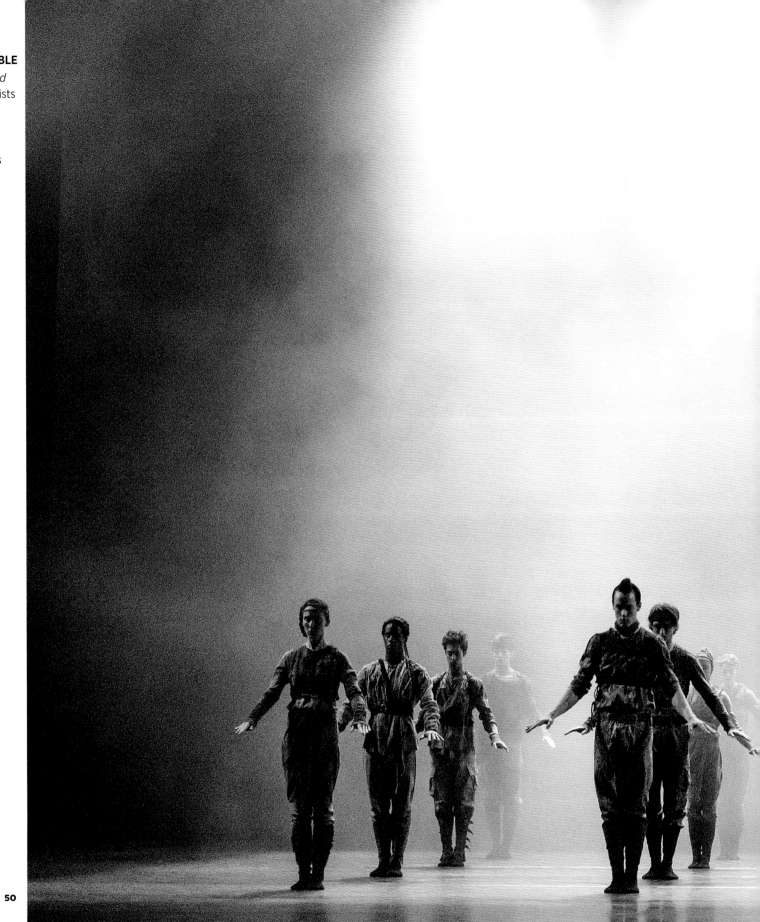

UNTOUCHABLE

This page and overleaf: Artists of The Royal Ballet

©2015 ROH. Photographs by Tristram Kenton

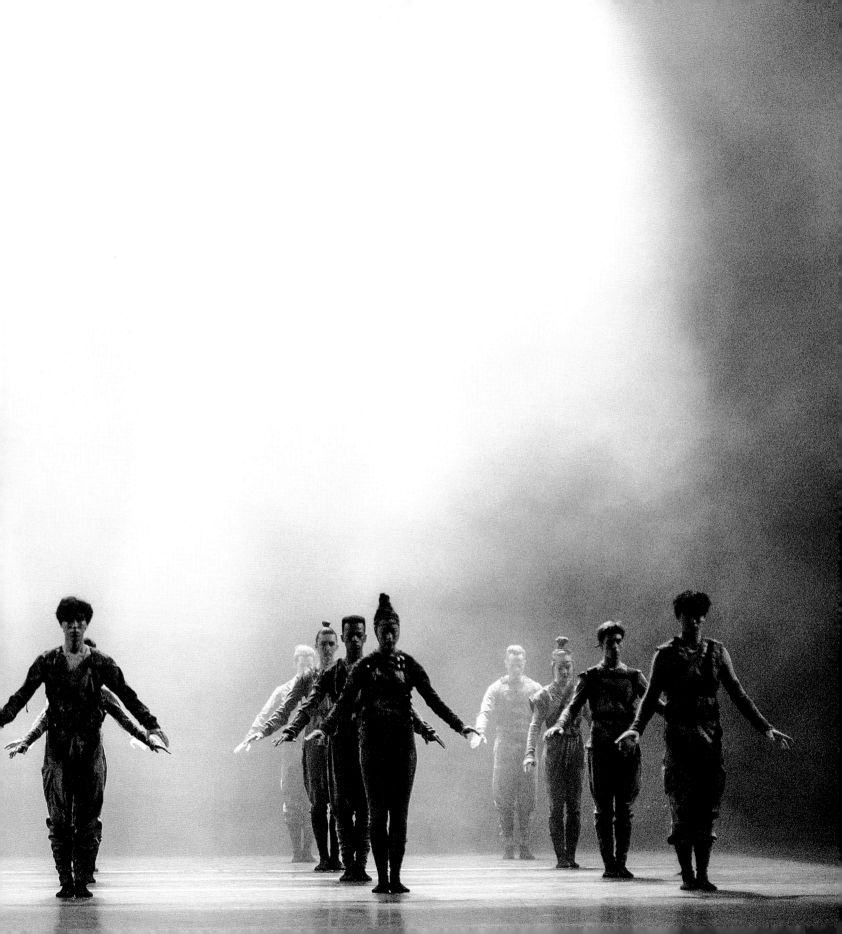

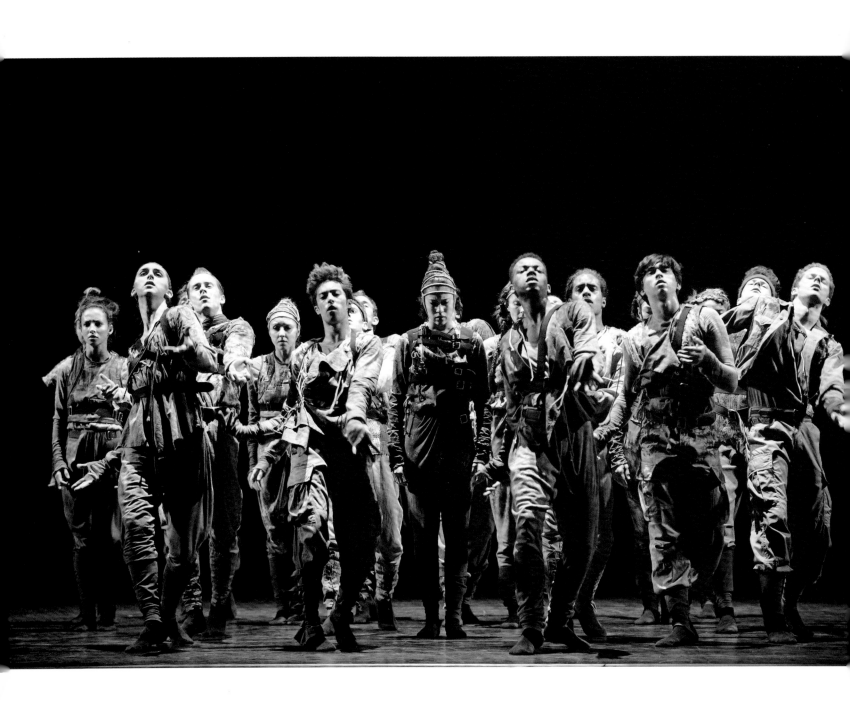

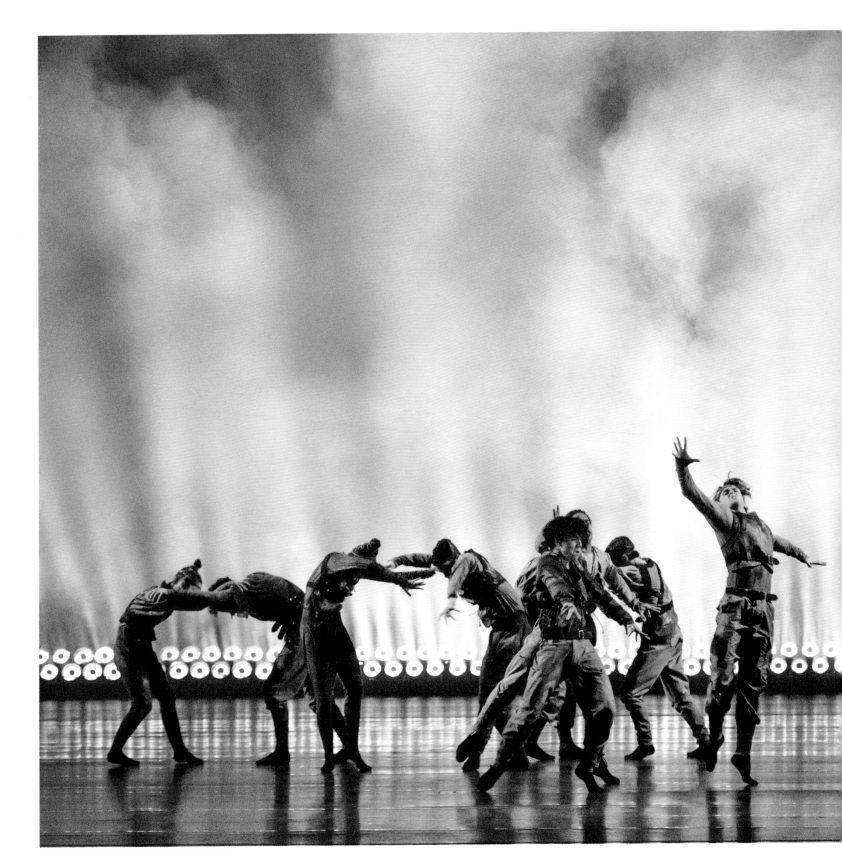

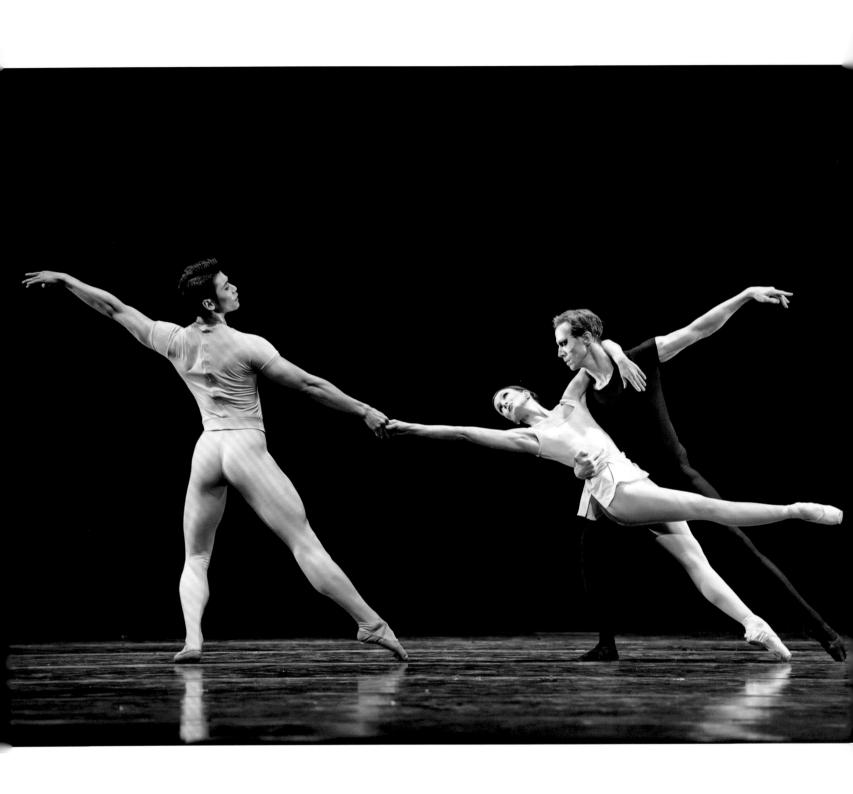

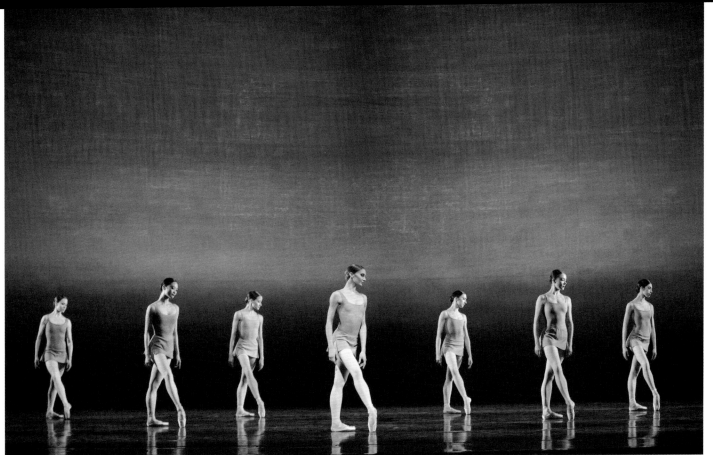

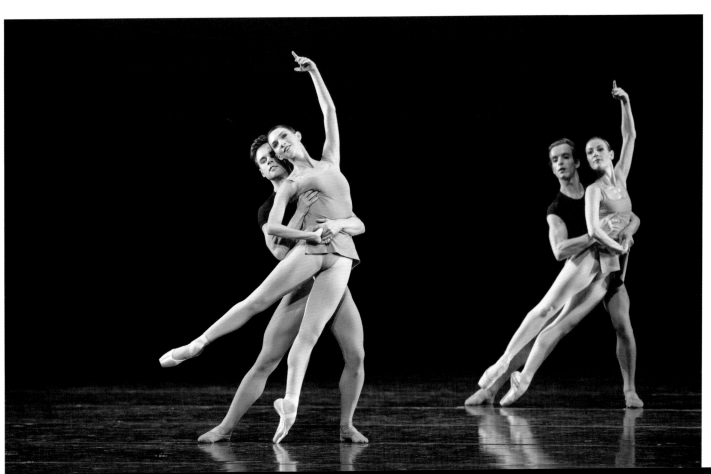

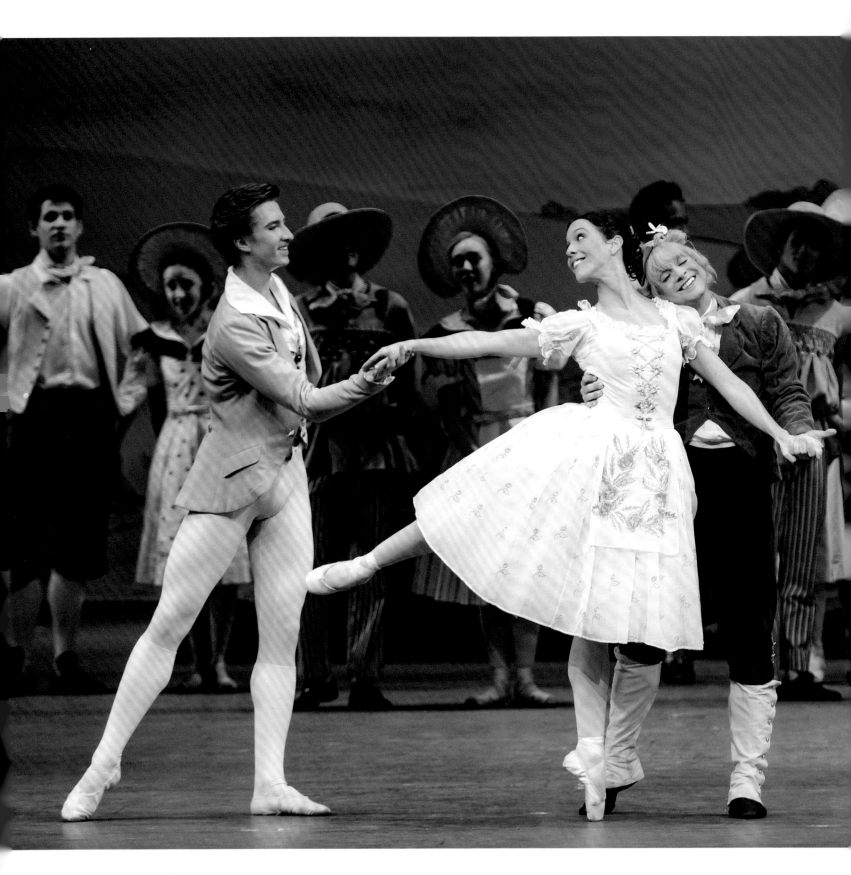

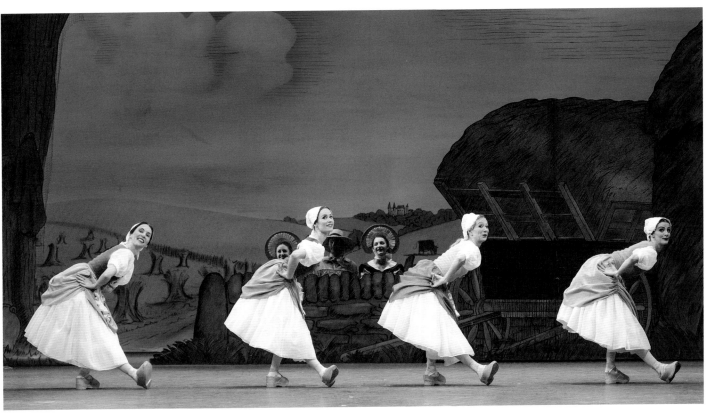

LA FILLE MAL GARDÉE

Opposite page: Vadim Muntagirov as Colas, Laura Morera as Lise and Paul Kay as Alain

This page:

Top: Kristen McNally, Emma Maguire, Sian Murphy and Olivia Cowley

Below: Michael Stojko as the Notary's Clerk, Philip Mosley as Widow Simone, Gary Avis as the Village Notary and Christopher Saunders as Thomas

©2015 ROH. Photographs by Tristram Kenton

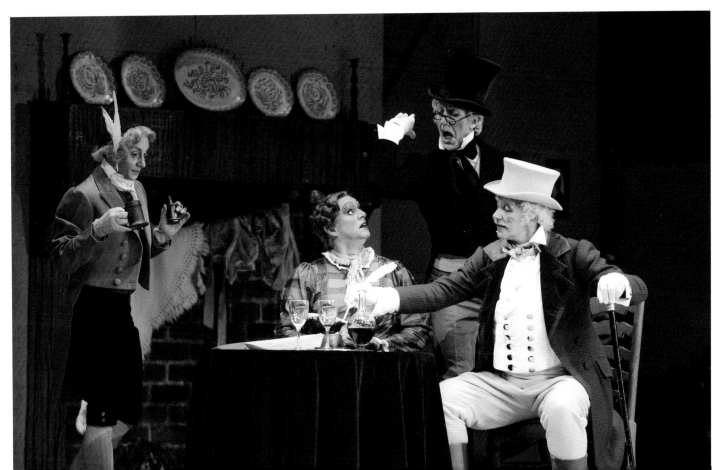

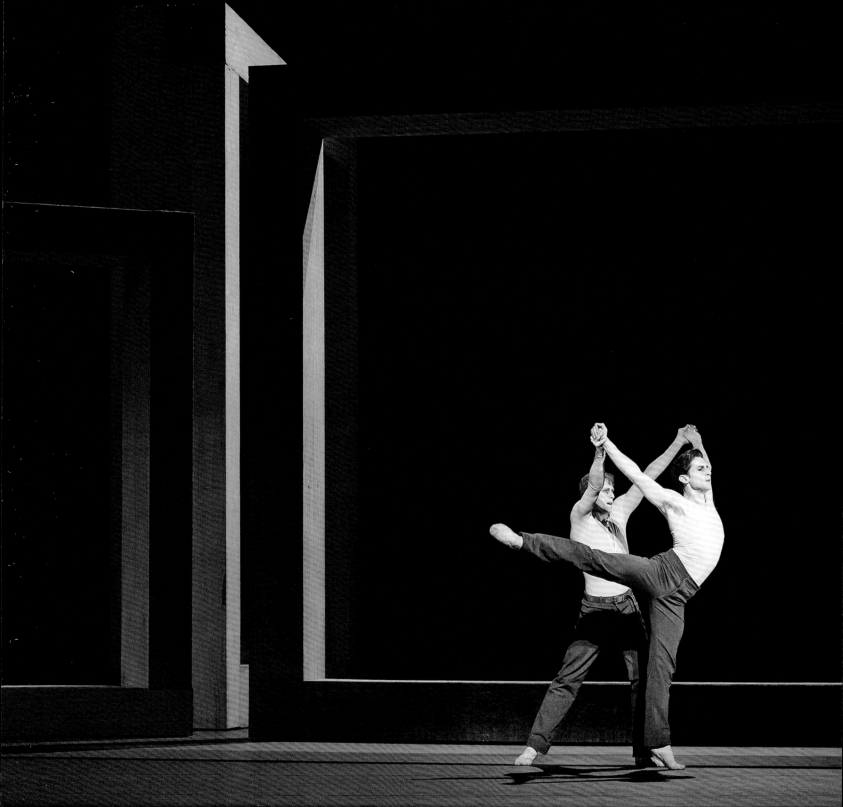

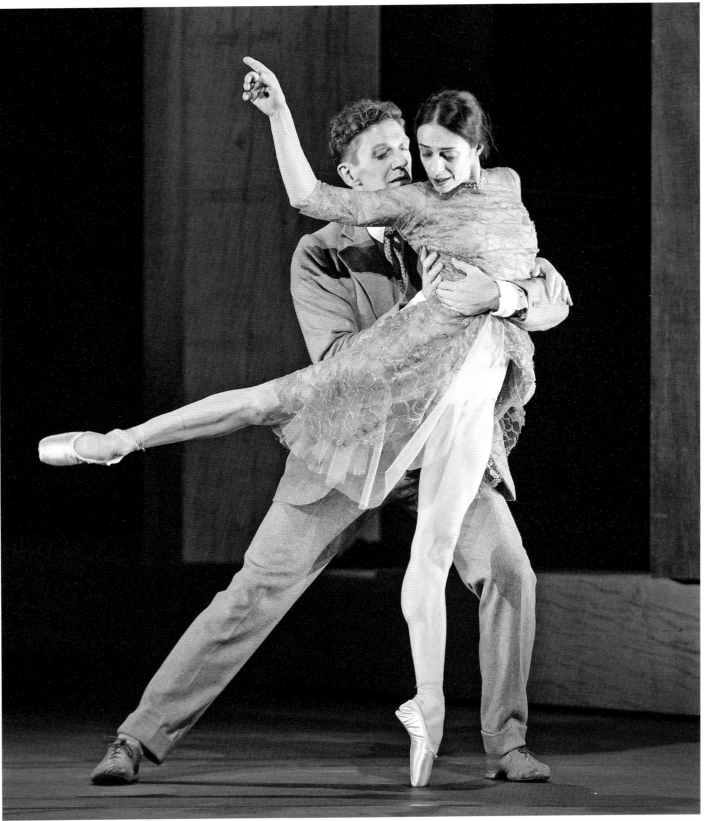

WOOLF WORKS

Opposite page: Edward Watson and Tristan Dyer

This page: Alessandra Ferri and Gary Avis

©2015 ROH. Photographs by Tristram Kenton

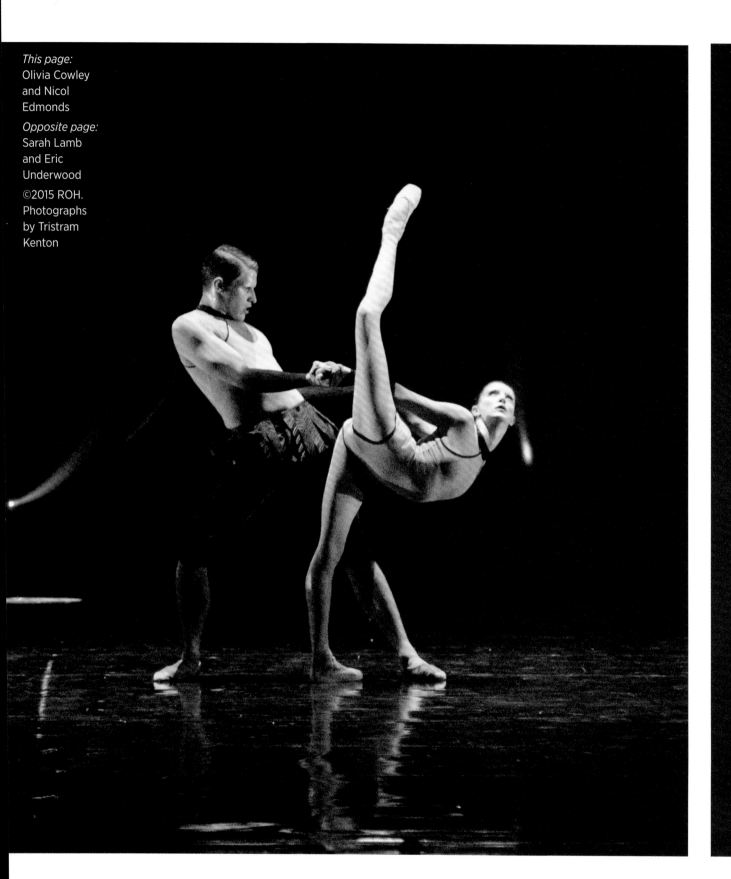

This page:
Olivia Cowley
and Nicol
Edmonds

Opposite page:
Sarah Lamb
and Eric
Underwood

©2015 ROH.
Photographs
by Tristram
Kenton

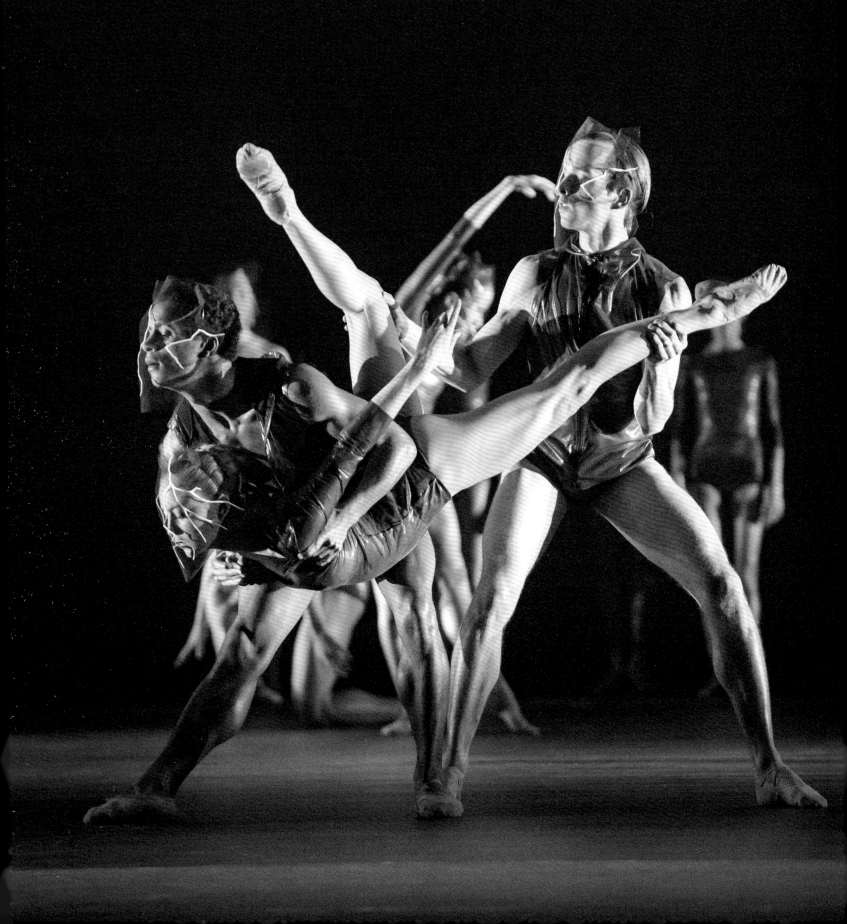

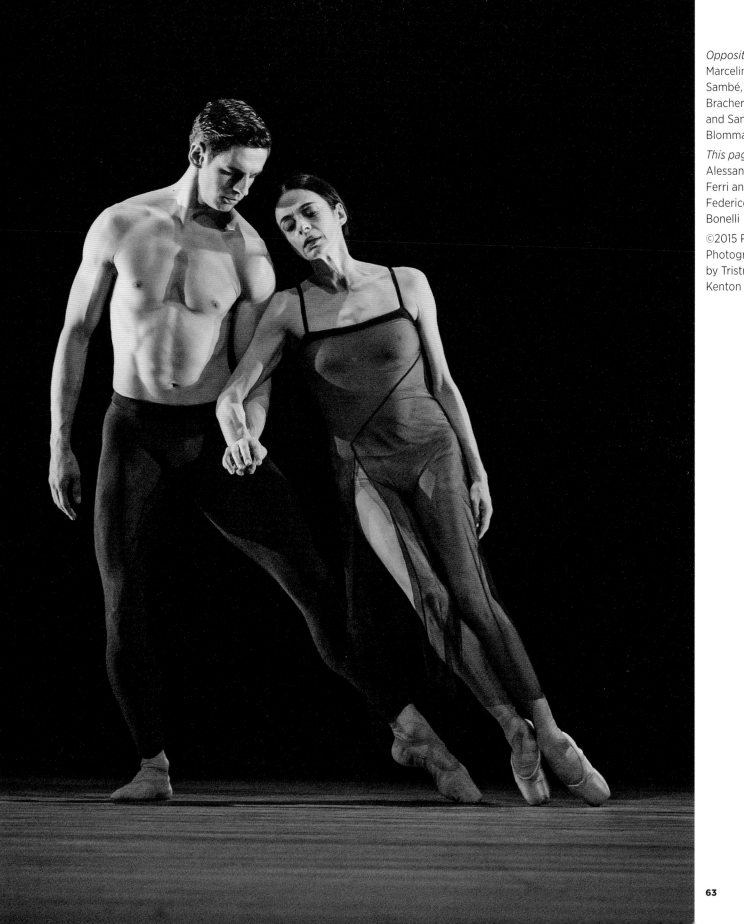

Opposite page:
Marcelino
Sambé, Camille
Bracher
and Sander
Blommaert

This page:
Alessandra
Ferri and
Federico
Bonelli

©2015 ROH.
Photographs
by Tristram
Kenton

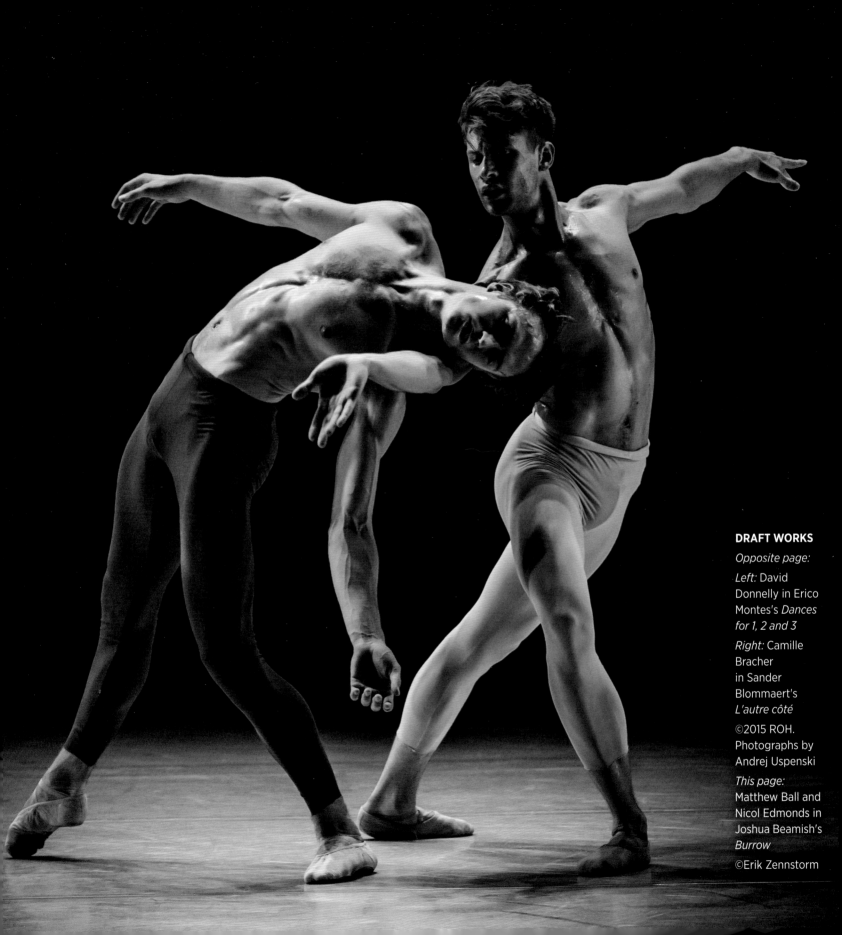

DRAFT WORKS

Opposite page:

Left: David Donnelly in Erico Montes's *Dances for 1, 2 and 3*

Right: Camille Bracher in Sander Blommaert's *L'autre côté*

©2015 ROH. Photographs by Andrej Uspenski

This page: Matthew Ball and Nicol Edmonds in Joshua Beamish's *Burrow*

©Erik Zennstorm

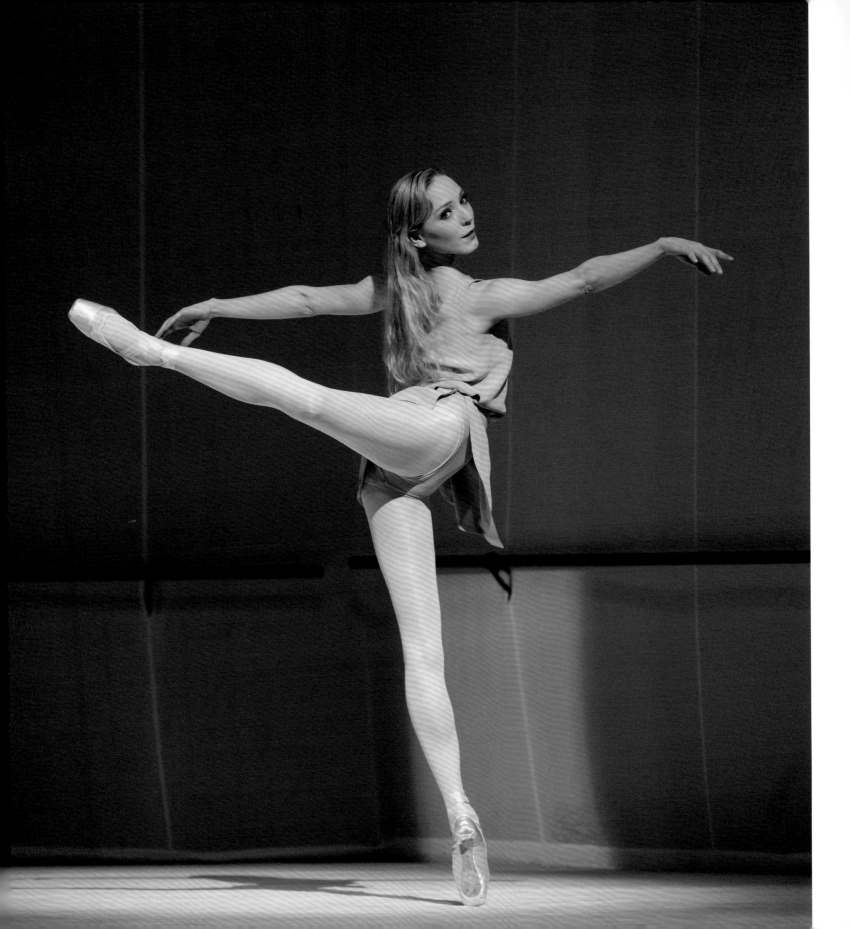

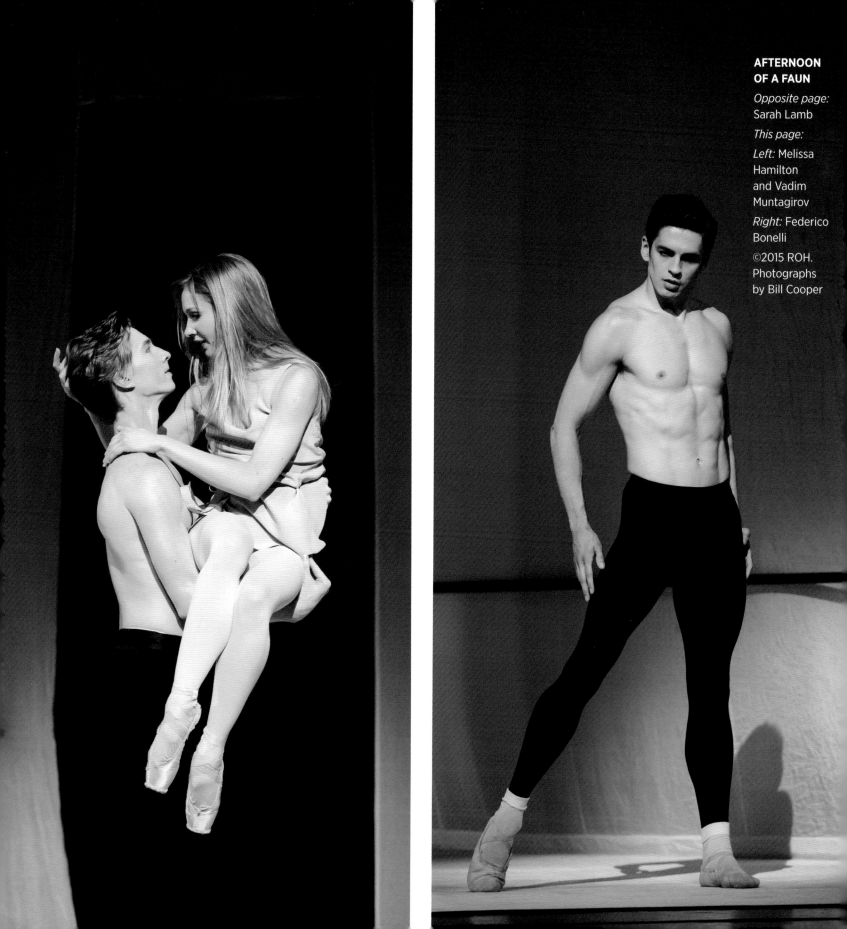

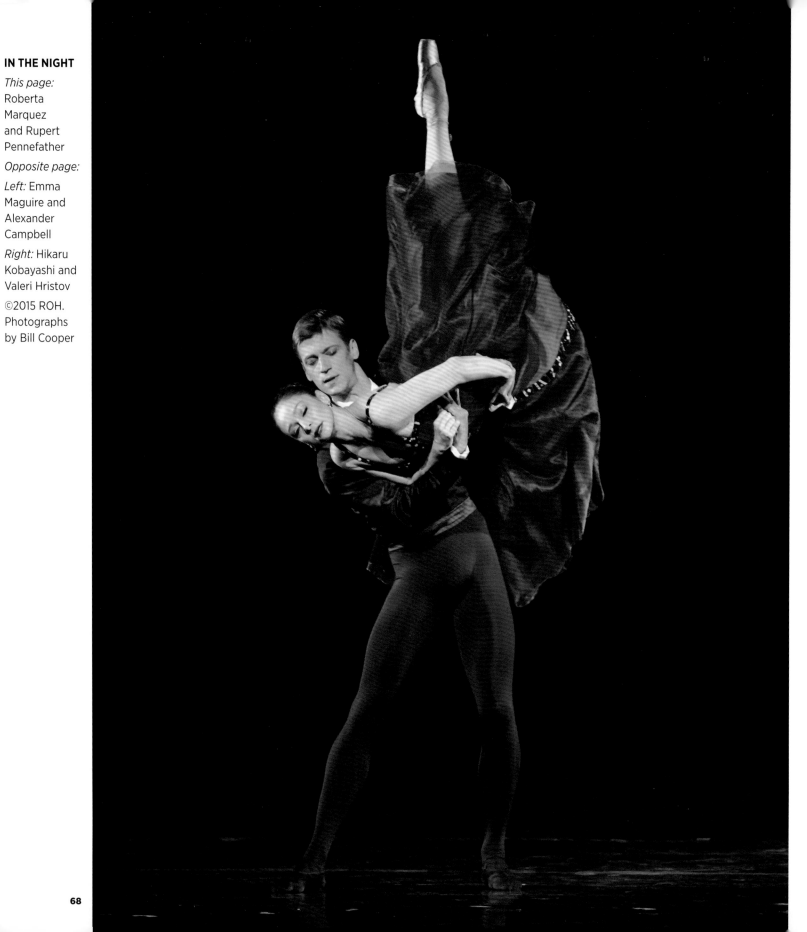

IN THE NIGHT

This page: Roberta Marquez and Rupert Pennefather

Opposite page:

Left: Emma Maguire and Alexander Campbell

Right: Hikaru Kobayashi and Valeri Hristov

©2015 ROH. Photographs by Bill Cooper

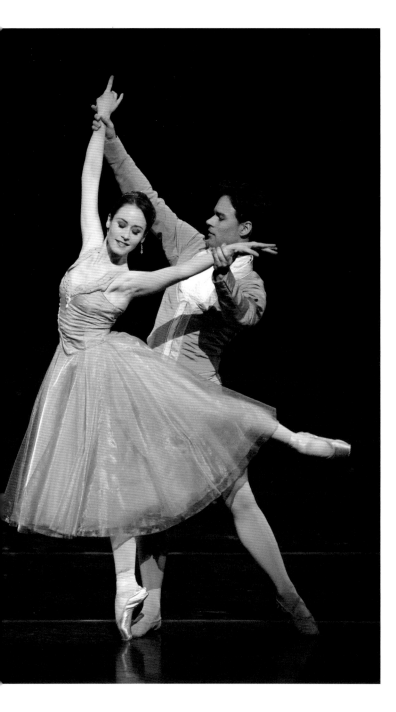

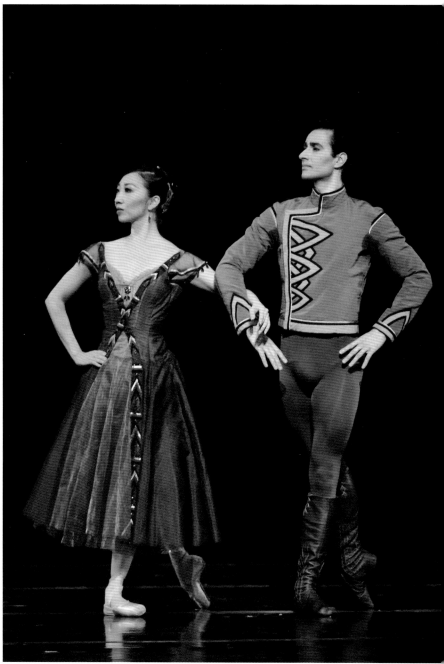

P20 MANON

Choreography Kenneth MacMillan
Music Jules Massenet
orchestrated by Martin Yates,
originally compiled by
Leighton Lucas *with the
collaboration of* Hilda Gaunt

Conductor Martin Yates
Designs Nicholas Georgiadis
Lighting design John B. Read
Staging Julie Lincoln,
Christopher Saunders
Senior Ballet Master
Christopher Saunders
Ballet Mistress Samantha Raine
Principal coaching Alexander
Agadzhanov, Lesley Collier,
Jonathan Cope, Anthony Dowell,
Julie Lincoln

Premiere
7 March 1974
(The Royal Ballet)

P22 SCÈNES DE BALLET

Choreography Frederick Ashton
Music Igor Stravinsky

Conductor Emmanuel Plasson
Designs André Beaurepaire
Lighting design John B. Read
Staging Christopher Carr
Ballet Mistress Samantha Raine
Principal coaching Christopher Carr,
Lesley Collier, Antoinette Sibley
Benesh Notator Gregory Mislin

Premiere
11 February 1948
(Sadler's Wells Ballet)

**P24 FIVE BRAHMS WALTZES
IN THE MANNER OF
ISADORA DUNCAN**

Choreography Frederick Ashton
Music Johannes Brahms

Conductor Emmanuel Plasson
Costume designs David Dean
Lighting design John B. Read
Ballet Mistress Samantha Raine

Premieres
15 June 1976
(Ballet Rambert,
Sadler's Well Theatre)
23 November 1976
(The Royal Ballet, this production)

P26 SYMPHONIC VARIATIONS

Choreography Frederick Ashton
Music César Franck

Conductor Emmanuel Plasson
Designs Sophie Fedorovitch
Lighting design John B. Read
Staging Wendy Ellis Somes,
Malin Thoors
Assistant Ballet Master
Ricardo Cervera

Premiere
24 April 1946
(Sadler's Wells Ballet)

P28 A MONTH IN THE COUNTRY

Choreography Frederick Ashton
Music Fryderyk Chopin
arranged by John Lanchbery

Conductor Emmanuel Plasson
Lighting design William Bundy
re-created by John Charlton
Staging Anthony Dowell,
Grant Coyle
Principal coaching Anthony Dowell,
Jonathan Cope

Premiere
12 February 1976
(The Royal Ballet)

P30 CEREMONY OF INNOCENCE

Choreography Kim Brandstrup
Music Benjamin Britten

Conductor Barry Wordsworth
Costume designs Kandis Cook
Designs Leo Warner
for 59 Productions
Lighting design Jordan Tuinman
Assistant to the Choreographer
Deirdre Chapman

Premieres
21 June 2013
(The Royal Ballet/Dance East,
Snape Maltings Concert Hall)
7 November 2014
(The Royal Ballet)

P32 THE AGE OF ANXIETY (NEW)

Choreography Liam Scarlett
Music Leonard Bernstein

Conductor Barry Wordsworth
Designs John Macfarlane
Lighting Jennifer Tipton
Benesh Notator Gregory Mislin

Premiere
7 November 2014
(The Royal Ballet)

P36 AETERNUM

Choreography
Christopher Wheeldon
Music Benjamin Britten

Conductor Barry Wordsworth
Designs Jean-Marc Puissant
Assistant to the Choreographer
Jacquelin Barrett
Assistant Ballet Master
Jonathan Howells
Benesh Notator Anna Trevien

Premiere
22 February 2013
(The Royal Ballet)

P38 CASSANDRA (NEW)
LINBURY STUDIO THEATRE

Choreography Ludovic Ondeviela
Music Ana Silvera

Film director Kate Church
Designs Becs Andrews
Lighting design Paul Keogan

Premiere
30 October 2014

P40 DON QUIXOTE

Production and Choreography
Carlos Acosta *after* Marius Petipa
Music Ludwig Minkus
*arranged and orchestrated
by* Martin Yates

Conductor Martin Yates
Designs Tim Hatley
Lighting design Hugh Vanstone
Ballet Master Christopher Saunders
Ballet Mistress Samantha Raine
Principal coaching Carlos Acosta,
Alexander Agadzhanov, Lesley
Collier, Jonathan Cope
Benesh Notator Anna Trevien

Premiere
5 October 2013
(The Royal Ballet)

**P42 ALICE'S ADVENTURES IN
WONDERLAND**

Choreography
Christopher Wheeldon
Music Joby Talbot, *orchestrated by*
Christopher Austin and Joby Talbot

Conductor David Briskin
Designs Bob Crowley
Scenario Nicholas Wright
Lighting design Natasha Katz
Projection design Jon Driscoll and
Gemma Carrington
Original sound design
Andrew Bruce for Autograph
Staging Christopher Saunders
Ballet Master Christopher Saunders
Principal coaching Jonathan Cope
and Christopher Saunders
Benesh Notator Anna Trevien

Premiere
28 February 2011
(The Royal Ballet)

P44 ONEGIN

Choreography John Cranko
Music Kurt-Heinz Stolze
after Pytor Il'yich Tchaikovsky

Conductor Dominic Grier
Designs Jürgen Rose *after original
1969 designs for Stuttgart Ballet*
Lighting design Steen Bjarke
Staging Jane Bourne
Ballet Master Gary Avis
Ballet Mistress Samantha Raine
Principal coaching Alexander
Agadzhanov, Jane Bourne,
Lesley Collier, Jonathan Cope
Benesh Notator Gregory Mislin

Premieres
13 April 1965
(Stuttgart Ballet)
22 November 2001
(The Royal Ballet, this production)

P46 SWAN LAKE

Choreography Marius Petipa
and Lev Ivanov
Additional Choreography
Frederick Ashton
(Act III Neopolitan Dance)
and David Bintley
(Act I Waltz)
Music Pytor Il'yich Tchaikovsky

Conductor Boris Gruzin
Production Anthony Dowell
Designs Yolanda Sonnabend
Lighting design Mark Henderson
Production Research
Roland John Wiley
Staging Christopher Carr
Ballet Mistress Samantha Raine
Principal coaching Alexander
Agadzhanov, Lesley Collier,
Jonathan Cope, Olga Evreinoff
Benesh Notators Anna Trevien,
Gregory Mislin

Premieres
15 January 1895
(Mariinsky Theatre, St Petersburg)
13 March 1987
(The Royal Ballet, this production)

P48 THE FOUR TEMPERAMENTS

Choreography George Balanchine
Music Paul Hindemith

Conductor Bary Wordsworth
Lighting design John B. Read
Staging Patricia Neary
Ballet Master Christopher Saunders
Ballet Mistress Samantha Raine
Benesh Notator Anna Trevien

Premieres
20 November 1946
(Ballet Society, Central High School
of Needle Trades, New York)
25 January 1973
(The Royal Ballet)

P50 UNTOUCHABLE (NEW)

Choreography Hofesh Shechter
Music Hofesh Shechter
and Nell Catchpole

Conductor Koen Kessels
Costume designs Holly Waddington
Lighting design Lee Curran
Assistants to the Choreographer
Deirdre Chapman, Hope Muir,
Bruno Guillore, Chien-Ming Chang
Benesh Notator Gregory Mislin

Premiere
27 March 2015
(The Royal Ballet)

P54 SONG OF THE EARTH

Choreography Kenneth MacMillan
Music Gustav Mahler
*Text from Hans Bethge's 'The Chinese
Flute'*

Conductor Barry Wordsworth
Designs Nicholas Georgiadis
Lighting design John B. Read
Staging Monica Mason, Grant Coyle
Ballet Master Gary Avis
Principal coaching Monica Mason,
Gary Avis
Benesh Notator Grant Coyle

Premieres
7 November 1965
(Württembergische Staatstheatre
Ballet, Stuttgart)
19 May 1966
(The Royal Ballet)

P56 LA FILLE MAL GARDÉE

Choreography Frederick Ashton
Music Ferdinand Hérold
arranged and orchestrated
by John Lanchbery

Conductor Barry Wordsworth
Scenario Jean Dauberval
Designs Osbert Lancaster
Lighting design John B. Read
Staging Christopher Carr,
Grant Coyle
Ballet Mistress Samantha Raine
Principal coaching Alexander
Agadzhanov, Christopher Carr,
Lesley Collier, Donald MacLeary
Benesh Notator Grant Coyle

Premiere
28 January 1960
(The Royal Ballet)

P58 WOOLF WORKS (NEW)

Concept, Direction and Choreography
Wayne McGregor
Music Max Richter

Conductor Koen Kessels
Designs Ciguë, We Not I, Wayne
McGregor
Costume designs Moritz Junge
Lighting design Lucy Carter
Film design Ravi Deepres
Sound design Chris Ekers
Make-up design Kabuki
Dramaturg Uzma Hameed
Assistants to the Choreographer
Amanda Eyles, Jenny Tattersall

Premiere
11 May 2015
(The Royal Ballet)

P66 AFTERNOON OF A FAUN

Choreography Jerome Robbins
Music Claude Debussy

Conductor Barry Wordsworth
Costume designs Irene Sharaff
Set designs Jean Rosenthal
Original lighting design
Jean Rosenthal
recreated by Les Dickert

Premieres
14 May 1953
(New York City Ballet)
14 December 1971
(The Royal Ballet)

P68 IN THE NIGHT

Choreography Jerome Robbins
Music Fryderyk Chopin
Conductor Barry Wordsworth
Costume designs Anthony Dowell
Lighting design Jennifer Tipton
recreated by Les Dickert

Premieres
29 January 1970
(New York City Ballet)
10 October 1973
(The Royal Ballet)

THE 2014/15 SEASON IN REVIEW

NEW WORKS

Through the past few Seasons, new works have become as significant a feature of Royal Ballet repertory as the classics and heritage ballets. After all, every familiar favourite was new once. In 2014/15 there were five premieres of ballets new to the Company including four commissions created on its dancers.

Artist in Residence Liam Scarlett's latest creation for The Royal Ballet, *The Age of Anxiety*, was given a preview when a rehearsal of it was part of the first World Ballet Day, streamed online to show behind the scenes at five ballet companies from round the world. The full work is set to Bernstein's Symphony no.2 and was performed as part of a mixed programme in November 2014 by two exceptional casts. Laura Morera, Steven McRae, Bennet Gartside and Tristan Dyer created the four leading roles. With the Scarlett was the London premiere of Kim Brandstrup's impressionistic *Ceremony of Innocence* (new in 2013 at the Aldeburgh Festival as part of the celebrations of the centenary of Britten's birth) and Artistic Associate Christopher Wheeldon's Olivier Award-winning ballet also from 2013, *Aeternum*. The whole programme was well received ('decorous, sonorous, richly elegiac', *The Telegraph*).

In March, *Untouchable* was described as 'a milestone commission' for the Company (*The Guardian*). Visceral and immersive, Hofesh Shechter's first work for The Royal Ballet drew compelling performances from an ensemble of 20 dancers comprising Artists, First Artists and Soloists hand-picked by the Israeli choreographer.

There were many special ingredients in Resident Choreographer Wayne McGregor's first full-length ballet for the main stage, *Woolf Works*, which received its world premiere in May: inspiration from the life and work of Virginia Woolf, a commissioned score from award-winning British composer Max Richter, and even former Royal Ballet Principal Alessandra Ferri in a thrilling return to embody both Virginia Woolf and her fictional creation Clarissa Dalloway. It was a highlight of the Season and received many rave reviews from critics and audiences: *The Guardian* called it 'exhilarating and ravishingly expressive', and *The Stage* 'a new gold standard for neo-classical dance'.

The Royal Ballet Studio Programme in the Linbury Studio Theatre added to the new commissions. In October, choreographer and former First Artist Ludovic Ondiviela joined with singer-songwriter Ana Silvera and filmmaker Kate Church for *Cassandra*, a poignant exploration of what it is to be labelled mad. Olivia Cowley was 'instantly appealing as vulnerable Cassandra' (*DanceTabs*), and there were powerful performances from Gary Avis as her doctor and former Principal Mara Galeazzi, who returned to dance the role of Cassandra's mother.

In December, ZooNation's wonderfully wacky family hip-hop show *The Mad Hatter's Tea Party* was performed in the Linbury at the same time as a revival of Christopher Wheeldon's magical family ballet *Alice's Adventures in Wonderland* on the main stage. Issac 'Turbo' Baptiste – the *Tea Party*'s Mad Hatter – also took part in a thrilling dance-off against Steven McRae, creator of the Mad Hatter in Wheeldon's *Alice*, cheered on by a studio packed with excited youngsters from St Joseph's Primary School in Covent Garden.

Artists of The Royal Ballet in rehearsal for Hofesh Shechter's *Untouchable* ©2015 ROH. Photograph by Tristram Kenton

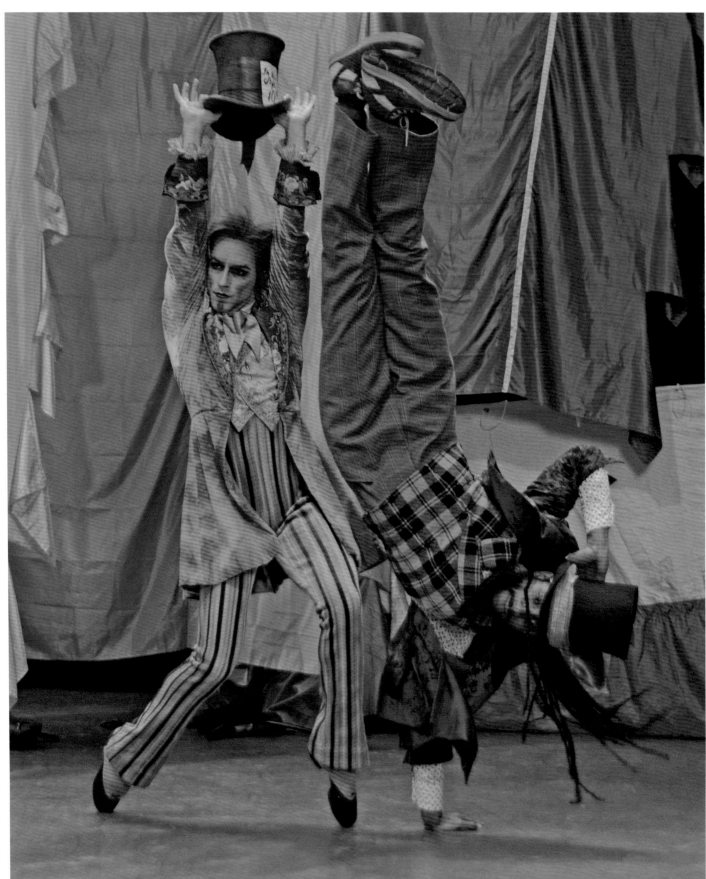

Royal Ballet
Principal
Steven McRae
and ZooNation
Dance
Company's
Issac 'Turbo'
Baptiste
©Dave Morgan

The Royal Ballet's annual Draft Works programme took place in February in the Linbury, with new works choreographed by Company dancers Valentino Zucchetti, Sander Blommaert, Erico Montes and Marcelino Sambé, as well as dancers from other companies. In addition to this the first Draft Works National presented new work from Company dancers and participating companies from across the country including Wayne McGregor | Random Dance, Rambert, Scottish Ballet and Northern Ballet.

Other visiting companies to the Linbury during the Season included BalletBoyz, Phoenix Dance, London international Mime Festival, Aakash Odedra, Ballet Black, Ballet de Lorraine, Shobana Jeyasingh Dance Company, Northern Ballet, Northern School of Contemporary Dance, Dutch National Ballet Junior Company and Central School of Ballet.

In July, former New York City Ballet principal Wendy Whelan and Royal Ballet Principal Edward Watson performed in their own unique collaboration with five world-renowned choreographers – Danièle Desnoyers, Javier de Frutos, Annie-B Parson, Arlene Philips and Arthur Pita – in *Whelan/Watson: Other Stories*. In 2016 the collaboration will tour to City Centre in New York, with additional work by Christopher Wheeldon.

CONTEMPORARY REVIVALS

There were two stunning revivals of recent full-length Royal Ballet works, both involving the whole Company. Carlos Acosta's vibrant production of *Don Quixote* returned in November, and also delighted audiences in Chicago and Washington D.C. during the USA tour at the end of the Season. There were energetic, virtuoso performances from the whole cast. Acosta himself partnered Marianela Nuñez, who 'has made the role of Kitri her own, and Acosta brings every ounce of his considerable charm and virtuosity to bear as Basilio' (*The Guardian*). Guest Principal Iana Salenko returned as Kitri, once again partnered by Steven McRae. Debuts in this production included Natalia Osipova as Kitri and Matthew Golding as Basilio.

When Wheeldon's *Alice's Adventures in Wonderland* was performed over Christmas and New Year, there were a number of notable role debuts, including Francesca Hayward as Alice alongside Vadim Muntagirov as Jack/Knave of Hearts, and Alexander Campbell and James Hay as Lewis Carroll/White Rabbit. Both Hayward and Hay are promoted to First Soloist for the 2015/16 Season.

Choreographic talent from within The Royal Ballet was once more on show during the tour to New York in June. Among the *divertissements* performed by the Company were Alastair Marriott's *Borrowed Light* – with Marcelino Sambé and Luca Acri, both of whom are promoted to Soloist for the 2015/16 Season – and Calvin Richardson's contemporary reimagining of Anna Pavlova's famous solo *The Dying Swan*, danced by Richardson himself and also by Matthew Ball.

COMPANY CLASSICS

No Royal Ballet Season would be complete without revivals of defining ballets from the Company's unique heritage. In its 40th anniversary year, Kenneth MacMillan's modern masterpiece *Manon* was performed with no fewer than five casts dancing the roles of the doomed Manon and the love-lorn student Des

Grieux – there were role debuts from Melissa Hamilton and Francesca Hayward as Manon and Vadim Muntagirov and Matthew Golding as Des Grieux. Carlos Acosta also made a debut: in the role of Manon's brother, Lescaut. The ballet launched the Royal Opera House 2014/15 Live Cinema Season when it was broadcast live to 26,000 people in 378 cinemas in the UK alone.

MacMillan's breathtaking *Song of the Earth* appeared in two programmes towards the end of the Season, and was performed again in New York on the USA tour. A notable debut was given by Lauren Cuthbertson, who was highly praised for her first performances after a spell of injury – 'Cuthbertson told the truth; the choreography lived, and eloquently so' (*Financial Times*).

In October a mixed programme displayed the extraordinary breadth of the genius of Frederick Ashton, The Royal Ballet's Founder Choreographer. Masterworks *Scènes de ballet* and *Symphonic Variations* were performed alongside his poignant *A Month in the Country* and the strikingly contemporary *Five Brahms Waltzes in the Manner of Isadora Duncan*. A host of excellent role debuts, including those of Yuhui Choe, Steven McRae and Valentino Zucchetti in *Scènes*; Melissa Hamilton, Marianela Nuñez, Matthew Golding, Vadim Muntagirov and Reece Clarke in *Symphonic Variations*; Natalia Osipova and Francesca Hayward in *Month*, and Helen Crawford and Romany Pajdak in *Five Brahms Waltzes*.

La Fille mal gardée, Ashton's sunny ballet inspired by his beloved Suffolk countryside, returned in April. Natalia Osipova made her debut as Lise opposite Steven McRae as Colas, and the pair starred in the live cinema broadcast in May. Further notable debuts were given by Vadim Muntagirov and Alexander Campbell as Colas.

A highlight of the Learning and Participation activities this Season were the Chance to Dance performances at the end of May in the Linbury Studio Theatre. Francesca Hayward, Anna Rose O'Sullivan, James Hay, Marcelino Sambé and Thomas Whitehead all gave spirited accounts of the lead roles in *La Fille mal gardée*, delighting audiences alongside the children of the Chance to Dance Company. Two associated film features appeared on *Blue Peter* and all concerned were thrilled to receive their *Blue Peter* badges.

The Season also included a revival of Anthony Dowell's sumptuous production of *Swan Lake*, based on the popular 1895 revision of the classic by Lev Ivanov and Marius Petipa. The production once again featured noteworthy Company debuts – from Akane Takada as Odette/Odile and from Vadim Muntagirov and Matthew Golding as Prince Siegfried – and also performances from Guest Principal Evgenia Obraztsova.

INTERNATIONAL FAVOURITES

When John Cranko's *Onegin* was revived in January, Natalia Osipova gave another highly praised debut performance, as Tatiana – 'she has genius... that quality for which one prays in a theatre' – alongside Matthew Golding, the 'clever, casually callous Onegin... who invests the role with extreme subtlety' (*The Telegraph*). Itziar Mendizabal and Nehemiah Kish also gave beautiful first performances in these roles, and Vadim Muntagirov, Nicol Edmonds and

Matthew Ball all impressed in their debuts as Lensky (for the 2015/16 Season Edmonds is promoted to Soloist and Ball is promoted to First Artist).

Ballets by George Balanchine and his protégé Jerome Robbins added American flavour to the Season. Balanchine's radiant *The Four Temperaments* completed the Spring mixed programme along with *Untouchable* and *Song of the Earth*. Debuts were given in its fiercely challenging solos by a host of the Company's principals and soloists. Also programmed alongside *Song of the Earth* in the last programme of the Season were Robbins's gems *Afternoon of a Faun* and *In the Night*: two ballets with highly nuanced *pas de deux* at their cores, illustrating the choreographer's credo that 'dance is about relationships'. Notable first performances were given by Melissa Hamilton and Vadim Muntagirov in *Faun*, and Marianela Nuñez and Thiago Soares in the stormy third *pas de deux* of *In the Night*.

LIFE REIMAGINED

In February, the Royal Opera House celebrated the full spectrum of talent that is presented throughout each Season with a special gala evening curated by Kevin O'Hare and Kasper Holten, Director of Opera for The Royal Opera. Alongside opera and music performances, The Royal Ballet presented a dance selection that included two new pieces created specially for the evening. Kim Brandstrup choreographed a *pas de deux* for Laura Morera and Federico Bonelli, '*See, even Night herself is here*', to music by Purcell from *The Fairy Queen*, and Liam Scarlett created *Summertime*, a new *pas de deux* danced by Melissa Hamilton and Matthew Golding. The Company performed The Cards, an extract from Act III of Wheeldon's *Alice's Adventures in Wonderland*, Olivia Cowley and Edward Watson danced McGregor's *Qualia pas de deux*, Natalia Osipova and Steven McRae danced Balanchine's *Tchaikovsky pas de deux*, Marianela Nuñez and Thiago Soares danced the 'Diamonds' *pas de deux* from *Jewels* and Carlos Acosta and Sarah Lamb danced MacMillan's 'If I loved you' *pas de deux* from *Carousel*. The entire Royal Ballet School danced their signature Grand Défilé, and the Chance to Dance Company opened the evening with an extract from David Bintley's *'Still Life' at the Penguin Café*, with Alexander Campbell the soloist in the role of the Texan Kangaroo Rat.

FURTHER AFIELD

The 2014 Royal Ballet tour took the Company to the Bolshoi Theatre in Moscow with two performances of a mixed programme containing Ashton's *Rhapsody*, McGregor's *Tetractys* and Wheeldon's *DGV: Danse à grande vitesse*. The *Financial Times* described Steven McRae in *Rhapsody* as 'fiendishly brilliant in the role created for Baryshnikov'. Then came four performances of *Manon* that brought Natalia Osipova and Carlos Acosta together in the Principal roles for the first time. After Moscow, the Company flew to Taipei for four performances of *Romeo and Juliet* to sold-out audiences at the Taipei National Theatre. One performance was broadcast live to big screens in Taipei, Chiayi and P'ingtung – making for an even larger audience, with many watching ballet for the very first time. Next was the Grand Theatre in Shanghai for four performances of Acosta's *Don Quixote*.

Then, just before the start of the Season, a group of the Company's dancers gave a run of four performances at Copenhagen's Tivoli Concert Hall.

Brandstrup's *Ceremony of Innocence* was performed ahead of its London premiere in November, with a number of *divertissements*. The Queen of Denmark was present at opening night.

In June 2015, after their final performance of the Season at the Royal Opera House, the Company flew to the USA. Audiences in the Auditorium Theater in Chicago and Kennedy Center in Washington were treated to performances of *Don Quixote*, which was praised in the *Washington Post* as being 'fresh and alive'. The Company then travelled to New York for two contrasting programmes presented by the Joyce Theater at the David H. Koch Theater. *Song of the Earth* was revived alongside Ashton's delightful Shakespearean ballet *The Dream*, performed 50 years after it was first seen in the USA. *The Dream* was danced at a celebratory gala held on 23 June which also honoured Artistic Associate Christopher Wheeldon. The other mixed programme featured McGregor's *Infra*, Scarlett's *The Age of Anxiety* and a number of *divertissements*, in which the Company were described in the *New York Times* as leaving a 'bright and engaging impression'.

AWARDS AND ACCOLADES

It was certainly a great Season of awards and honours for The Royal Ballet and its associates. Jeanetta Laurence was awarded the OBE in the Queen's New Year Honours. Also in January, at the National Dance Awards, Natalia Osipova won the award for Outstanding Female Performance (for her performances in *Giselle*) and the Grishko Award for Best Female Dancer, while Carlos Acosta was presented with the De Valois Award for Outstanding Achievement, Francesca Hayward won the Grishko Award for Emerging Artist and Christopher Wheeldon's *The Winter's Tale* won him the award for Best Classical Choreography.

The Winter's Tale also swept the board at the Benois de la Danse awards in May – Wheeldon once again won an award for Best Choreography, while Joby Talbot's score for the ballet and Edward Watson's performance in the role of Leontes saw them awarded the Best Score and Best Dancer awards respectively. Watson was also awarded an MBE in the Queen's Birthday Honours List. Elsewhere, Wheeldon's adaptation of *An American in Paris* (Théâtre du Châtelet, Broadway), which stars Royal Ballet First Artist Leanne Cope as Lise, won a plethora of accolades, including a Tony Award for Best Choreography.

PRINCIPAL GUEST ARTISTS AND PRINCIPALS

PRINCIPAL GUEST ARTIST

PRINCIPALS

Carlos Acosta
Joined as Principal 1998
Principal Guest Artist 2003
Born: Havana, Cuba
Trained: National Ballet
School of Cuba
Previous Companies:
English National Ballet (1991),
National Ballet of Cuba (1992),
Houston Ballet (1993)

Federico Bonelli
Joined as Principal 2003
Born: Genoa, Italy
Trained: Turin Dance Academy
Previous Companies: Zürich
Ballet (1996), Dutch National
Ballet (1999)

Lauren Cuthbertson
Joined 2002
Promoted to Principal 2008
Born: Devon, England
Trained:
The Royal Ballet School

Matthew Golding
Joined as Principal 2014
Born: Sasketchewan, Canada
Trained: Royal Winnipeg
Ballet, Universal Ballet
Academy and The Royal Ballet
School
Previous Companies:
American Ballet Theatre
(2003), Dutch National Ballet
(2009)

Nehemiah Kish
Joined as Principal 2010
Born: Michigan, USA
Trained: National Ballet
School of Canada
Previous Companies: National
Ballet of Canada (2001),
Royal Danish Ballet (2008)

Sarah Lamb
Joined 2004
Promoted to Principal 2006
Born: Boston, USA
Trained: Boston Ballet School
Previous Company: Boston
Ballet (1998)

Roberta Marquez
Joined and promoted to
Principal 2004
Born: Rio de Janeiro, Brazil
Trained: Maria Olenewa State
Dance School
Previous Company:
Theatro Municipal, Rio de
Janeiro (1994)

Steven McRae
Joined 2004
Promoted to Principal 2009
Born: Sydney, Australia
Trained:
The Royal Ballet School

Laura Morera
Joined 1995
Promoted to Principal 2007
Born: Madrid, Spain
Trained:
The Royal Ballet School

Vadim Muntagirov
Joined as Principal 2014
Born: Chelyabinsk, Russia
Trained: Perm Choreographic
Institute and The Royal
Ballet School
Previous Company: English
National Ballet (2009)

Marianela Nuñez
Joined 1998
Promoted to Principal 2002
Born: Buenos Aires
Trained:
Teatro Colón Ballet School,
The Royal Ballet School

Natalia Osipova
Joined as Principal 2013
Born: Moscow
Trained: Bolshoi Ballet
Academy
Previous Companies: Bolshoi
Ballet (2004), American Ballet
Theatre (2010), Mikhailovsky
Theatre (2011)

Thiago Soares
Joined 2002
Promoted to Principal 2006
Born: São Gonçalo, Brazil
Trained: Centre for Dance,
Rio de Janeiro
Previous Company:
Theatro Municipal, Rio de
Janeiro (1998)

Edward Watson
Joined 1994
Promoted to Principal 2005
Born: Bromley, England
Trained:
The Royal Ballet School

Zenaida Yanowsky
Joined 1994
Promoted to Principal 2001
Born: Lyon, France
Trained: Las Palmas, Majorca
Previous Company: Paris
Opéra Ballet (1994)

PRINCIPAL CHARACTER ARTISTS, CHARACTER ARTISTS, FIRST SOLOISTS AND SOLOISTS

**PRINCIPAL
CHARACTER
ARTISTS**
Left to right:
Gary Avis
Alastair Marriott
**Elizabeth
McGorian**
Genesia Rosato

**Christopher
Saunders**

**CHARACTER
ARTIST**

Philip Mosley

FIRST SOLOISTS
Left to right:
**Alexander
Campbell**
Ricardo Cervera
Yuhui Choe
Helen Crawford

Bennet Gartside
Melissa Hamilton
James Hay
**Francesca
Hayward**

Ryoichi Hirano

Valeri Hristov

Hikaru Kobayashi

Itziar Mendizabal

Johannes Stepanek

Akane Takada

Valentino Zucchetti

SOLOISTS
Left to right:

Luca Acri

Christina Arestis

Claire Calvert

Olivia Cowley

Tristan Dyer

Nicol Edmonds

Elizabeth Harrod

Meaghan Grace Hinkis

SOLOISTS, FIRST ARTISTS AND ARTISTS

Jonathan Howells
Fumi Kaneko
Paul Kay
Emma Maguire

Laura McCulloch
Kristen McNally
Fernando Montaño
Yasmine Naghdi

Marcelino Sambé
Beatriz Stix-Brunell
Eric Underwood
Thomas Whitehead

FIRST ARTISTS
Left to right:
Matthew Ball
Tara-Brigitte Bhavnani
Sander Blommaert
Camille Bracher

Leanne Cope
Kevin Emerton
Hayley Forskitt
Nathalie Harrison

Mayara Magri
Thomas Mock
Erico Montes
Sian Murphy

Romany Pajdak
Gemma
Pitchley-Gale
Leticia Stock
Donald Thom

Lara Turk
James Wilkie

ARTISTS
Left to right:
Grace Blundell
Annette Buvoli

ARTISTS

Reece Clarke
Ashley Dean
David Donnelly
Téo Dubreuil

Benjamin Ella
Isabella Gasparini
Solomon Golding
Hannah Grennell

Tierney Heap
Chisato Katsura
Anna Rose O'Sullivan
Demelza Parish

Calvin Richardson
Mariko Sasaki
Gina Storm-Jensen
David Yudes

**AUD JEBSEN
YOUNG DANCERS
PROGRAMME**
Left to right:

**Lukas Bjørneboe
Brændsrød**

Harry Churches

Leo Dixon

Isabel Lubach

Julia Roscoe

**PRIX DE
LAUSANNE
DANCER**

Julian MacKay

Director
Kevin O'Hare

©Joe Plimmer

THE ROYAL BALLET 2015/16

Patron HM The Queen
President HRH The Prince of Wales
Vice-President The Lady Sarah Chatto

Director††† Kevin O'Hare
Music Director Koen Kessels

Resident Choreographer Wayne McGregor CBE
Artistic Associate†††† Christopher Wheeldon

General Manager
Heather Baxter

**Company and
Tour Manager**
Andrew Hurst

**Artistic Scheduling Manager
and Character Artist**
Philip Mosley

Artistic Administrator
Rachel Hollings

Financial Controller
Cathy Helweg

Deputy Company Manager
Elizabeth Ferguson

Assistant to the Directors
Lettie Heywood

**Administrative
Co-ordinator**
Yvonne Hunte

**Management
Accountant**
Orsola Ricciardelli

Video Archive Manager
Bennet Gartside

Photographer
Andrej Uspenski

Administrative Assistant
Isobel Rogers

**Clinical Director,
Ballet Healthcare**
Gregory Retter

**Chartered
Physiotherapist**
Caryl Becker
Nathan Evans
Moira McCormack
Daniel Watson

Pilates Instructor
Jane Paris

Gyrotonic Instructor
Fiona Kleckham

Occupational Psychologist
Britt Tajet-Foxell

**Ballet Rehabilitation
Specialist and Class
Teacher**
Brian Maloney

Masseurs
Tatina Semprini
Konrad Simpson
Helen Wellington

Sports Science
Frank Appel
Gregor Rosenkranz

Rehabilitation Coach
Ursula Hageli

Medical Advisor
Ian Beasley

**Healthcare Team
Coordinator**
Olivia Powell

Senior Ballet Master
Christopher Saunders

Ballet Master
Gary Avis

Ballet Mistress
Samantha Raine

**Assistant Ballet
Master**
Ricardo Cervera
Jonathan Howells

**Assistant Ballet
Mistress**
Laura McCulloch

**Senior Teacher and
Répétiteur to the
Principal Artists**
Alexander
Agadzhanov

Répétiteurs
Lesley Collier
Jonathan Cope

Senior Benesh Notator
Anna Trevien

Benesh Notator
Gregory Mislin

**Education Administrator
and Teacher**
David Pickering

Artist in Residence
Liam Scarlett

**Young Choreographer
Programme**
Charlotte Edmonds

Head of Music Staff
Robert Clark

Music Staff
Richard Coates
Philip Cornfield
Craig Edwards
Grant Green
Tim Qualtrough
Kate Shipway
Colin J. Scott*
Paul Stobart

Music Administrator
Nigel Bates

**Studio Programme
Senior Producer**
Emma Southworth

Assistant Producer
Hannah Mayhew

Project Manager
Francesca Moseley

**Governors of the
Royal Ballet Companies**

Chairman
Dame Jenny
 Abramsky DBE

**Guest Principal
Ballet Master**
Christopher Carr

Principal Guest Teacher
Elizabeth Anderton

Guest Teachers
Boris Akimov
Jacquelin Barrett
Wes Chapman
Johnny Eliasen
Olga Evreinoff
Antonia Franceschi
Nanette Glushak
Andrey Klemm
Alessandra Pasquali
Roland Price

Principal Guest Conductor
Barry Wordsworth

Conductors
David Briskin
Boris Gruzin
Tim Murray
Emmanuel Plasson
Esa-Pekka Salonen
Tom Seligman
Martin Yates

Principals
Carlos Acosta†
Federico Bonelli
Lauren Cuthbertson
Matthew Golding
Nehemiah Kish
Sarah Lamb
Roberta Marquez
Steven McRae
Laura Morera
Vadim Muntagirov
Marianela Nuñez
Natalia Osipova
Iana Salenko††
Thiago Soares
Edward Watson
Zenaida Yanowsky

**Principal Character
Artists**
Gary Avis
Alastair Marriott
Elizabeth McGorian
Genesia Rosato
Christopher Saunders
Will Tuckett††

Professor Michael
 Clarke CBE DL
Ricki Gail Conway
Stephen Hough CBE
Desmond Kelly OBE
Thomas Lynch

First Soloists
Alexander Campbell
Ricardo Cervera
Yuhui Choe
Helen Crawford
Bennet Gartside
Melissa Hamilton
James Hay
Francesca Hayward
Ryoichi Hirano
Valeri Hristov
Hikaru Kobayashi
Itziar Mendizabal
Johannes Stepanek
Akane Takada
Valentino Zucchetti

Soloists
Luca Acri
Christina Arestis
Claire Calvert
Olivia Cowley
Tristan Dyer
Nicol Edmonds
Elizabeth Harrod
Meaghan Grace Hinkis
Jonathan Howells
Fumi Kaneko
Paul Kay
Emma Maguire
Laura McCulloch
Kristen McNally
Fernando Montaño
Yasmine Naghdi
Marcelino Sambé
Beatriz Stix-Brunell
Eric Underwood
Thomas Whitehead

First Artists
Matthew Ball
Tara-Brigitte Bhavnani
Sander Blommaert
Camille Bracher
Leanne Cope
Kevin Emerton
Hayley Forskitt
Nathalie Harrison
Mayara Magri
Tomas Mock
Erico Montes
Sian Murphy
Romany Pajdak
Gemma Pitchley-Gale
Leticia Stock
Donald Thom
Lara Turk
James Wilkie

Artists
Grace Blundell
Annette Buvoli
Reece Clarke

Gail Monahan
Christopher Nourse
Marguerite Porter MBE
Simon Robey
Dame Sue Street DCB

Ashley Dean
David Donnelly
Téo Dubreuil
Benjamin Ella
Isabella Gasparini
Solomon Golding
Hannah Grennell
Tierney Heap
Chisato Katsura
Anna Rose O'Sullivan
Demelza Parish
Calvin Richardson
Mariko Sasaki
Gina Storm-Jensen
David Yudes

**Aud Jebsen
Young Dancers
Programme**
Lukas Bjørneboe
 Brændsrød
Harry Churches
Leo Dixon
Isabel Lubach
Julia Roscoe

**Prix de Lausanne
dancer**
Julian MacKay

The Duchess of
 Wellington OBE
Monica Zamora

Honorary Secretary
Peter Wilson

† Principal Guest Artist
†† Guest Artist
††† Position generously
 supported by Lady Ashcroft
†††† Position generously
 supported by Kenneth and
 Susan Green
* Jette Parker Young Artist

A COMPANY CHRONOLOGY

1931 20 January Bizet's opera *Carmen* is staged at the newly reopened Sadler's Wells Theatre with dancers from a fledgling ballet company, the Vic-Wells Opera Ballet, under the creative direction of their founder Ninette de Valois. The product of many developments of this company is today's Royal Ballet. **5 May** The Company gives a performance of short works by De Valois at Lilian Baylis's Old Vic theatre. Baylis's use of dancers in operas and plays enables De Valois to bring her emerging Company together. **July** The Camargo Society presents the Company in a programme that includes De Valois's *Job* and two works by Frederick Ashton, a young dancer also beginning to choreograph.

1932 January Alicia Markova becomes a regular Guest Artist with the Company, alongside Anton Dolin. **March** Revival of *Les Sylphides* with Markova and Dolin. **September** The Company tours for the first time, to Denmark. **October** The Company first performs classical repertory with Act II of *Le Lac des cygnes*.

1933 March Nicholas Sergeyev stages a full-length *Coppélia*, with Lydia Lopokova as Swanilda. Sergeyev, former *régisseur général* of the Mariinsky Theatre, brought written notation of classic Russian ballets to the West after fleeing Russia in the wake of the October Revolution.

1934 January Sergeyev stages *Giselle*, with Markova and Dolin. **April** Sergeyev stages *Casse-Noisette*. **20 November** The Company performs *Le Lac des cygnes* in full, with Markova and new Company Principal Robert Helpmann.

1935 Ashton becomes Resident Choreographer. **20 May** Premiere of De Valois's *The Rake's Progress*, with Markova as the Betrayed Girl. **26 November** Premiere of Ashton's *Le Baiser de la fée*. The cast includes the young Margot Fonteyn.

1937 The Company represents British culture at the International Exhibition in Paris. Their performances include the premiere of De Valois's *Checkmate*. **16 February** Premiere of Ashton's *Les Patineurs*. **27 April** Premiere of Ashton's *A Wedding Bouquet*. **5 October** London premiere of *Checkmate*.

1939 2 February Sergeyev stages *The Sleeping Princess*, with Fonteyn and Helpmann.

1940 23 January Premiere of Ashton's *Dante Sonata*. **May** The Company tours to the Netherlands. **November** The Company begins wartime tours throughout Britain.

1941 The New Theatre, St Martin's Lane, becomes the Company's home for much of the war. *The Sleeping Princess* is revived.

1942 19 May Premiere of Helpmann's ballet *Hamlet*, with Helpmann in the title role.

1944 26 October Premiere of Helpmann's *Miracle in the Gorbals*.

1945 The Company tours the Continent with the Entertainments National Service Association (ENSA).

1946 20 February The Company becomes resident at Covent Garden, and after the War reopens the Royal Opera House with *The Sleeping Beauty*. **24 April** Premiere of Ashton's *Symphonic Variations*.

1947 February *The Three-Cornered Hat* and *La Boutique fantasque* are revived by Leonid Massine, one of the biggest stars of Diaghilev's Ballets Russes, at De Valois's invitation.

1948 23 December Premiere of Ashton's *Cinderella*, the Company's first home-grown full-length ballet.

1949 9 October The Company performs *The Sleeping Beauty* in New York at the start of a hugely successful tour to many cities in the USA and Canada.

1950 20 February Premiere of De Valois's production of *Don Quixote*. **5 April** George Balanchine and his New York City Ballet make their first European visit. Balanchine revives his *Ballet Imperial* for the Company. **5 May** Premiere of Roland Petit's *Ballabile*. **September** The Company embarks on a five-month, 32-city tour of the USA.

1951 21 August Music Director Constant Lambert dies, aged 45. With De Valois and Ashton, Lambert was one of the chief architects of the Company.

1952 3 September Premiere of Ashton's *Sylvia*.

1953 2 June Premiere of Ashton's *Homage to the Queen*, as part of a coronation gala for HM The Queen.

1954 23 August The Company performs *The Firebird* at the Edinburgh Festival on the 25th anniversary of Dhiagilev's death. Margot Fonteyn takes the title role.

1956 1 March Premiere of Kenneth MacMillan's *Noctambules*, his first ballet for the Company. **31 October** Sadler's Wells Ballet, Sadler's Wells Theatre Ballet and the School are granted a Royal Charter. The main Company becomes The Royal Ballet.

1957 1 January Premiere of John Cranko's *The Prince of the Pagodas*, with a new score by Benjamin Britten. This is the Company's first full-length work to a commissioned score.

1958 27 October Premiere of Ashton's *Ondine*, with a new score by Hans Werner Henze, and Fonteyn in the title role.

1959 13 March Company premiere of MacMillan's *Danses concertantes*, created for Sadler's Wells Theatre Ballet in 1955.

1960 28 January Premiere of Ashton's *La Fille mal gardée*, with Nadia Nerina and David Blair.

1961 15 June The Company performs *Ondine* in Leningrad at the start of a tour to the USSR. The Kirov Ballet perform at Covent Garden as part of an exchange agreement. **14 February** The Royal Ballet Touring Company gives the premiere of Ashton's *Les Deux Pigeons* (later *The Two Pigeons*) with Lynn Seymour as Gourouli (later The Young Girl), Christopher Gable as Pepino (later The Young Man) and Elizabeth Anderton as the Gipsy Girl.

1962 21 February Rudolf Nureyev makes his Company debut in *Giselle* with Fonteyn, after his controversial defection from the Kirov in 1961. **3 May** Premiere of MacMillan's *The Rite of Spring*, with Monica Mason. **16 October** The Royal Ballet first performs Ashton's *The Two Pigeons*, with Lynn Seymour, Alexander Grant and Georgina Parkinson in the main roles.

1963 12 March Premiere of Ashton's *Marguerite and Armand*, with Fonteyn and Nureyev. **7 May** De Valois retires as Director of the Company, succeeded by Ashton. De Valois becomes Supervisor of The Royal Ballet School. **28 November** Nureyev stages the 'Kingdom of the Shades' scene from *La Bayadère*.

1964 29 February Antoinette Sibley dances Princess Aurora in the Company's 400th performance of *The Sleeping Beauty*. **2 April** Premiere of

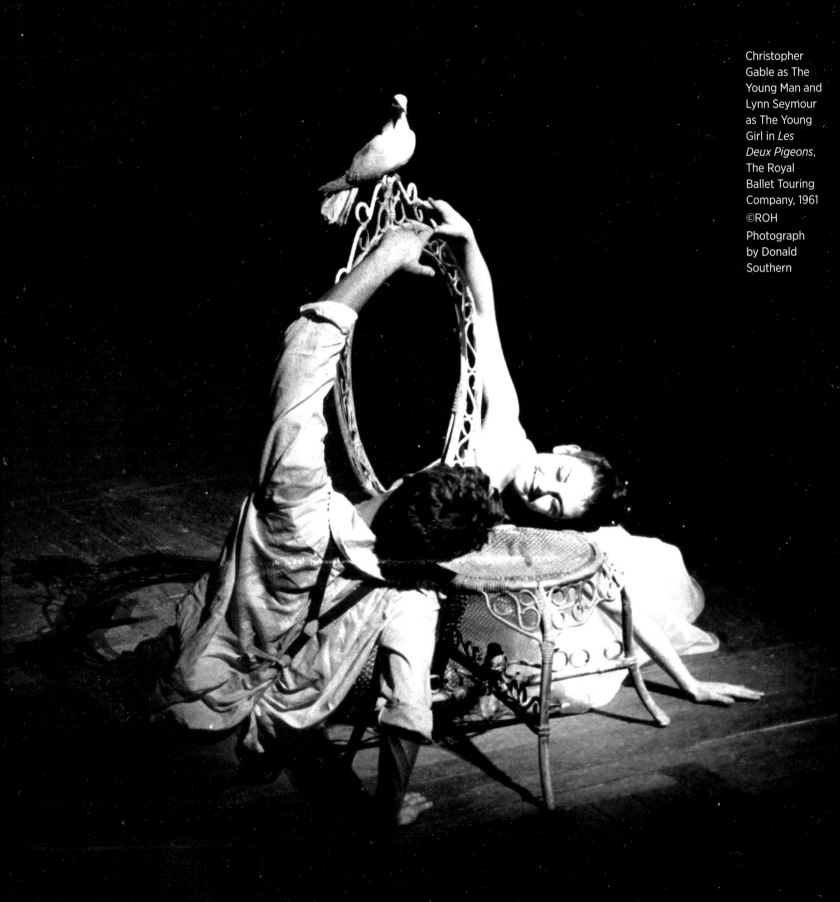

Ashton's *The Dream*, with Sibley and Anthony Dowell, as part of celebrations of the 400th anniversary of Shakespeare's birth. **2 December** Bronislava Nijinska revives her *Les Biches*, with Svetlana Beriosova as the Hostess.

1965 9 February Premiere of MacMillan's first full-length work, *Romeo and Juliet*, created on Lynn Seymour and Christopher Gable but danced on opening night by Fonteyn and Nureyev.

1966 23 March Nijinska revives her *Les Noces* in a mixed programme with *Les Biches*. **May** MacMillan becomes Director of Deutsche Oper Ballet, Berlin. **19 May** Company premiere of MacMillan's *Song of the Earth*, created for Cranko's Stuttgart Ballet in 1965.

1967 25 January Premiere of Antony Tudor's *Shadowplay*.

1968 29 February Premiere of Nureyev's staging of *The Nutcracker*. **26 April** Announcement of Ashton's retirement as Director in 1970 and his succession by MacMillan. **25 October** Premiere of Ashton's *Enigma Variations*.

1970s

1971 22 July Premiere of MacMillan's long-awaited *Anastasia*, with Seymour. **4 August** Premiere of Glen Tetley's contemporary ballet *Field Figures*.

1972 20 June Natalia Makarova makes her Company debut as a Guest Artist in *Giselle*, with Dowell.

1973 8 June Nureyev and Makarova dance *The Sleeping Beauty* together for the first time.

1974 7 March Premiere of MacMillan's *Manon, with* Sibley, Dowell and David Wall. **7 October** Premiere of MacMillan's *Elite Syncopations*, with Wayne Sleep in the Principal Character role.

1975 April The Royal Ballet makes its first tour of the Far East.

1976 12 February Premiere of Ashton's *A Month in the Country*, with Dowell and Seymour.

1977 13 June Norman Morrice succeeds MacMillan as Director of The Royal Ballet.

1978 14 February Premiere of MacMillan's *Mayerling*, with Wall and Seymour.

1980s

1980 13 March Premiere of MacMillan's *Gloria*. **4 August** Premiere of Ashton's *Rhapsody, with* Lesley Collier and Mikhail Baryshnikov, in celebration of the 80th birthday of HM Queen Elizabeth The Queen Mother.

1981 30 April Premiere of MacMillan's *Isadora* with Merle Park, in celebration of the Company's golden jubilee.

1982 2 December Premiere of Nureyev's *The Tempest*.

1984 24 February Premiere of MacMillan's *Different Drummer*. **20 December** Premiere of Peter Wright's production of *The Nutcracker*, with Collier and Dowell.

1986 Dowell succeeds Morrice as Director of The Royal Ballet.

1987 12 March Premiere of Dowell's production of *Swan Lake*, with Cynthia Harvey and Jonathan Cope. **16 December** Ashton revives his *Cinderella*, in his final production for the Company.

1988 9 March Premiere of David Bintley's *'Still Life' at the Penguin Café*. **10 May** Revival of Ashton's *Ondine*, after a 22-year absence from the Company's repertory. **19 August** Ashton dies.

1989 18 May Company premiere of the full-length *La Bayadère*, in a staging by Makarova. **8 December** Premiere of MacMillan's final, full-length ballet, *The Prince of the Pagodas*, with Darcey Bussell and Cope.

1990s

1990 19 July Bussell and Irek Mukhamedov perform MacMillan's *'Farewell' pas de deux* at a London Palladium gala.

1991 7 February Premiere of MacMillan's *Winter Dreams* (developed from the *'Farewell' pas de deux*). **2 May** Premiere of Bintley's *Cyrano*, in celebration of the Company's 60th anniversary.

1992 13 February Company premiere of William Forsythe's *In the middle, somewhat elevated*. **19 March** Premiere of MacMillan's last work, *The Judas Tree*, with Viviana Durante and Mukhamedov. **29 October** MacMillan dies backstage at the Royal Opera House during a revival of *Mayerling*. **6 December** Stage premiere of Ashton's *Tales of Beatrix Potter*.

1993 7 April Company premiere of Baryshnikov's *Don Quixote*.

1994 6 April Premiere of Dowell's new production of *The Sleeping Beauty* on tour in Washington D.C.. **18 June** Premiere of Ashley Page's *Fearful Symmetries*. **3 November** UK Premiere of Dowell's production of *The Sleeping Beauty*.

1996 2 May Revival of MacMillan's *Anastasia*, with new designs by Bob Crowley.

1997 14 July Farewell Gala and final performance before the Royal Opera House closes for refurbishment. During the closure The Royal Ballet performs at the Hammersmith Apollo, the Royal Festival Hall and the Barbican.

1999 23 November The Company marks the reopening of the Royal Opera House with 'A Celebration of International Choreography'. **17 December** Opening night of *The Nutcracker*, the first full-length ballet in the new House.

2000s

2000 8 February Revival of De Valois's production of *Coppélia*, using Osbert Lancaster's original designs. **29 February** Revival of Ashton's *Marguerite and Armand*, with Sylvie Guillem and Nicolas Le Riche. **6 May** Millicent Hodson and Kenneth Archer revive Nijinsky's *Jeux* in a programme with his *L'Après-midi d'un faune*.

2001 8 March De Valois dies. **July** Ross Stretton succeeds Dowell as Director of The Royal Ballet. **30 July** *Swan Lake* is the first full-length ballet to be broadcast to Big Screens. **23 October** Premiere of Nureyev's staging of *Don Quixote*. **22 November** Company premiere of Cranko's *Onegin*.

2002 September Ross Stretton resigns as Director. **December** Monica Mason becomes Director of the Company.

2003 13 January Company premiere of Jiří Kylián's *Sinfonietta*. **8 March** Premiere of Makarova's new production of *The Sleeping Beauty*. **April** Jeanetta Laurence appointed Assistant Director. **22 December** Premiere of Wendy Ellis Somes's new production of *Cinderella*.

2004 April The Company marks the 75th anniversary of Sergey Diaghilev's death in a programme that includes *Le Spectre de la rose*. **4 November** Revival of Ashton's full-length *Sylvia*, reconstructed and staged by Christopher Newton for the 'Ashton 100' celebrations.

2005 7 May Premiere of Christopher Bruce's *Three Songs – Two Voices*, inspired by the life of Jimi Hendrix.

2006 15 May The Company celebrates its 75th anniversary with a new production of the 1946 *Sleeping Beauty*, realized by Monica Mason and Christopher Newton with Messel's original designs, re-created by Peter Farmer. It is followed by revivals of Ashton's *Homage to The Queen*, with additional choreography by Christopher Wheeldon, Michael Corder and

David Bintley, and De Valois's *The Rake's Progress*. **8 June** HM The Queen attends a gala performance of *Homage to The Queen* with *La Valse* and *divertissements*. **November** Premieres of Wayne McGregor's *Chroma* and Wheeldon's *DGV: Danse à grande vitesse*. **December** McGregor becomes Resident Choreographer of The Royal Ballet.

2007 March Premiere of Alastair Marriott's *Children of Adam*. **April** Premiere of Will Tuckett's *The Seven Deadly Sins*. **June** Barry Wordsworth is appointed Music Director. **23 November** Company premiere of Balanchine's *Jewels*.

2008 28 February Premiere of Wheeldon's *Electric Counterpoint*. **23 April** Premiere of Kim Brandstrup's *Rushes – Fragments of a Lost Story*. **October** The 50th anniversary of Ashton's *Ondine*. **13 November** Premiere of McGregor's *Infra*. **28 December** *The Nutcracker* is broadcast live to cinemas around the world, in the Company's first cinema broadcast.

2009 March Anthony Russell-Roberts retires as Artistic Administrator and is succeeded by Kevin O'Hare. **April** Jeanetta Laurence is appointed Associate Director of The Royal Ballet. **17 November** Memorial service dedicated to the founders of The Royal Ballet held at Westminster Abbey.

2010 January 50th anniversary of Ashton's *La Fille mal gardée*. **5 May** Premiere of Liam Scarlett's *Asphodel Meadows*.

2011 28 February Premiere of Wheeldon's *Alice's Adventures in Wonderland*, to a commissioned score by Joby Talbot. **17–19 June** The Company appears at The O₂ Arena for the first time, performing MacMillan's *Romeo and Juliet*.

2012 23 March 'Royal Ballet Live', a day behind the scenes with The Royal Ballet, is broadcast live on the internet. **5 April** Premiere of McGregor's *Carbon Life* and Scarlett's *Sweet Violets*. **2 June** Revival of MacMillan's *The Prince of the Pagodas* after a 16-year absence from the Company's repertory. **15–20 June** Premiere of *Metamorphosis: Titian 2012*, a triptych of new works by Brandstrup and McGregor, Marriott and Wheeldon and Scarlett, Tuckett and Watkins, in collaboration with the National Gallery. **20 June** Mason retires as Director, succeeded by O'Hare. **July** Wheeldon is appointed Artistic Associate. **30 October** The Company celebrates HM The Queen's Diamond Jubilee in a gala performance. **November** Scarlett is appointed the Company's first Artist in Residence.

2013 22 February Premieres of Ratmansky's *24 Preludes* and Wheeldon's *Aeternum*. **February–March** Members of the Company tour to Brazil. **8 May** Premiere of Scarlett's *Hansel and Gretel*. **24 May** Premiere of McGregor's *Raven Girl*. **20 June** Premiere of Brandstrup's *Ceremony of Innocence* at the Aldeburgh Festival. **5 October** Premiere of Carlos Acosta's production of *Don Quixote*. **9 November** Premiere of David Dawson's *The Human Seasons*.

2014 7 February Premiere of McGregor's *Tetractys*. **10 April** Premiere of Wheeldon's *The Winter's Tale*. **May** 50th anniversary of Ashton's *The Dream*. **31 May** Premiere of Marriott's *Connectome*. **June** The Company tours to the Bolshoi Theatre, Moscow, Taipei and Shanghai. **7 November** Premiere of Scarlett's *The Age of Anxiety*.

2015 27 March Premiere of Hofesh Shechter's *Untouchable*. **11 May** Premiere of McGregor's *Woolf Works*. **June** Jeanetta Laurence retires as Assistant Director and Barry Wordsworth retires as Music Director. **September** 50th anniversary of MacMillan's *Romeo and Juliet*.

Lynn Seymour as Juliet and Christopher Gable as Romeo in *Romeo and Juliet* ©1965 Roy Round

SELECTED BOOKS ABOUT THE ROYAL BALLET AND ITS DANCERS

Carlos Acosta at The Royal Ballet

Carlos Acosta, for many years a leading light of The Royal Ballet and an international star, is a trailblazer of the dance world. Renowned for his extraordinary prowess and charisma on stage, he is a ballet hero of our times and an inspiration to the next generation of dancers.

Carlos Acosta at The Royal Ballet is a celebration of his phenomenal success and popularity with Royal Ballet audiences at Covent Garden and worldwide since 1998. The book contains over 150 images of Carlos on stage and in rehearsal. Ballet photographs include his own production of *Don Quixote* alongside *Giselle*, *Swan Lake*, *La Bayadère*, *La Fille mal gardée*, *Apollo*, *Romeo and Juliet*, *Manon* and *Requiem*, plus many more.

This superb quality photo-led book captures his greatest performances with The Royal Ballet, with tributes from three Royal Ballet directors – Anthony Dowell, Monica Mason and current Director Kevin O'Hare – Associate Director Jeanetta Laurence, and dancers and colleagues at the Royal Opera House.

ISBN 978-1-78319-890-0

Steven McRae – Dancer in the Fast Lane

By Andrej Uspenski

Steven McRae: Dancer in the Fast Lane is a collection of photographs of Royal Ballet Principal Steven McRae. Photographer and former Royal Ballet dancer Andrej Uspenski has once again used his exclusive vantage point to capture glimpses of Steven on stage and in rehearsal, for both classic and contemporary work with The Royal Ballet. Introduced by Steven McRae, and including images of Steven rehearsing Kenneth MacMillan's *Romeo and Juliet* with Guest Principal Evgenia Obraztsova. Oberon Books, 2014.

ISBN 978-1-78319-088-1

Dancers: Behind the Scenes with The Royal Ballet

By Andrej Uspenski

This beautifully produced book by former Royal Ballet dancer Andrej Uspenski is a collection of exclusive photographs which shines the spotlight on ballet, the most beautiful of art forms. These exquisite photographs feature some of the finest dancers on stage today, bringing the reader into the magical world of ballet. As a Royal Ballet dancer himself, Andrej Uspenski has a unique perspective on the photographic composition of dance imagery, as well as unrivalled access not only to The Royal Ballet's productions, but also to the dancers who perform in them. This gives the reader an exclusive insight into The Royal Ballet's work. *Dancers* includes exclusive, backstage photographs, as well as a number of breathtaking images taken from the wings during live stage performances, making this a unique photographic record, perfect for all ballet fans. Oberon Books, 2013.

ISBN 978-1-84943-388-4

Natalia Osipova: Becoming a Swan

By Andrej Uspenski

Natalia Osipova: Becoming a Swan is an intimate portrait of the work of Royal Ballet Principal Natalia Osipova. This story of a dancer preparing for the most iconic role in ballet, behind the scenes and on stage, with unique glimpses from the wings at the Royal Opera House, is told in more than 150 black and white images by Royal Ballet dancer Andrej Uspenski. This is a moving photographic tribute to one of the world's most exciting ballerinas. Foreword by Alexander Agadzhanov, The Royal Ballet's Senior Teacher and Répétiteur to the Principal Artists. Oberon Books, 2013.

ISBN 978-1-78319-022-5

Rudolf Nureyev
and The Royal Ballet

Black and white photographs documenting Rudolf Nureyev's long association with The Royal Ballet, edited by Cristina Franchi. Oberon Books, 2005.

ISBN 978-1-84002-462-3

Margot Fonteyn: Prima
Ballerina Assoluta of
The Royal Ballet

Black and white photographs documenting Margot Fonteyn's long association with The Royal Ballet, edited by Cristina Franchi. Oberon Books, 2004.

ISBN 978-1-84002-460-9

Frederick Ashton:
Founder Choreographer
of The Royal Ballet

Black and white photographs documenting Frederick Ashton's career and works made for The Royal Ballet, edited by Cristina Franchi. Oberon Books, 2004.

ISBN 978-1-84002-461-6

Royal Opera House
Souvenir Guide

Explore the Royal Opera House, its history, performance, architecture and backstage. Oberon Books, 2012

ISBN 978-1-84943-167-5

Pas de deux: The Royal Ballet in Pictures

More than two hundred stunning colour and black and white photographs of The Royal Ballet in rehearsal and performance. This is a unique photographic record of one of the foremost ballet companies in the world in performance and rehearsal at the Royal Opera House. Oberon Books, 2007.

ISBN 978-1-84002-777-8

The Royal Ballet 2014/15

The new edition for the 2014/15 season will bring all ballet lovers up to date with the latest activities, performances and company news from the prestigious Royal Ballet. Featuring lavish photographs of last Season's performances, a special preview of the new Season and lively and informative articles, the Yearbook is a richly illustrated companion to The Royal Ballet, its history, repertory, dancers and staff. Oberon Books, 2014.

ISBN 978-1-78319-081-2

An English Ballet

By Ninette de Valois
Edited by David Gayle

Historic talk and essay from the Founder of The Royal Ballet. Oberon Books, 2011.

ISBN 978-1-84943-107-1

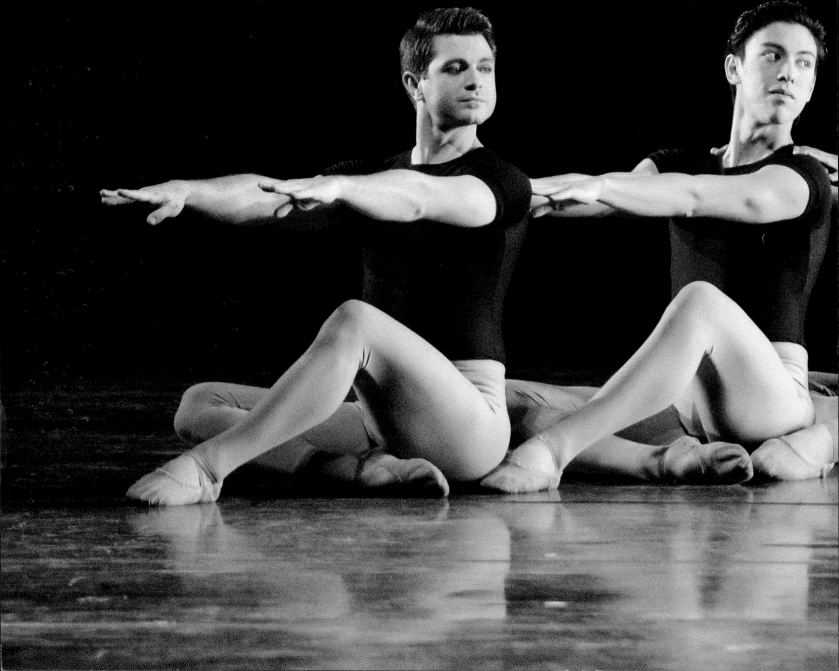